GOYA'

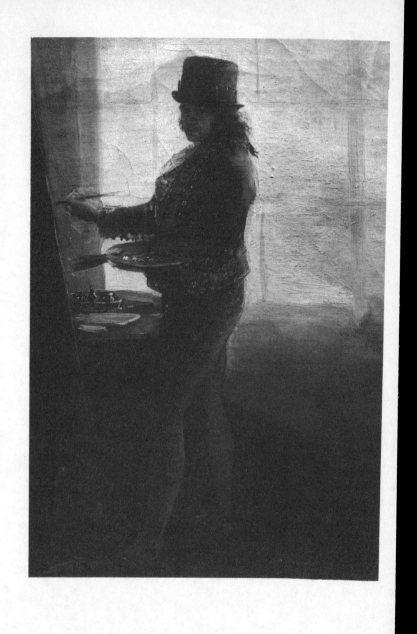

GOYA'S
LAST PORTRAIT
The Painter
Played Today

JOHN BERGER
AND
NELLA BIELSKI

faber and faber

LONDON · BOSTON

by John Berger and Nella Bielski

A QUESTION OF GEOGRAPHY

Self-portrait
(Conde de Villagonzalo, Madrid)

First published in 1989
by Faber and Faber Limited
3 Queen Square London WCIN 3AU
Reprinted 1989

Photoset by Parker Typesetting Service Leicester
Printed in Great Britain by
Richard Clay Ltd Bungay Suffolk

British Library Cataloguing in Publication Data
Berger, John, *1926–*
Goya's last portrait.
I. Title II. Bielski, Nella
822′.914
ISBN 0-571-15148-5

For Tony Lyons in Madrid

CHARACTERS

GARDENER elderly
PEPA his daughter, early twenties
LEANDRO gardener's assistant, twenty-five
WIDOW sixty
DWARF a beggar, ageless
TONIO footballer, early thirties
FEDERICO Minister of Agriculture, fifty
ACTRESS twenty-five
DOCTOR fifty-five
GOYA

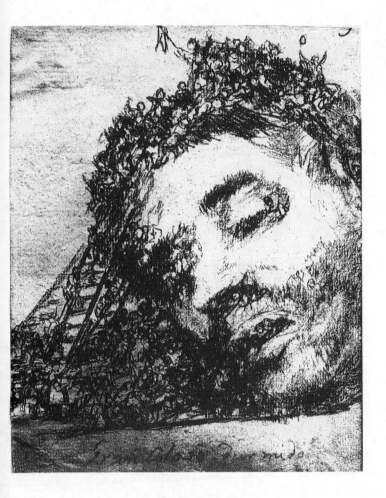

Sleeping giant
(drawing now destroyed)

*Late afternoon. Summer. The 1990s. A little-used corner of a cemetery
on a hill in Madrid. The tombs are overgrown. In the centre a ruin
which was once a chapel. Near left: door to the gardener's house. By
the door, a large bell. Far right: path leading to nearest gate of
cemetery. Near right: a* DWARF, *who is a professional beggar, sleeps
in the grass. In the ruined chapel a* WIDOW, *in black, is on her knees
murmuring the refrain of a prayer in Latin. Left: the elderly*
GARDENER, *masked and gloved, is bent over a beehive. Beside him,*
PEPA, *his daughter, is working a smoker to quieten the bees.*
LEANDRO, *a worker in the cemetery, crosses backstage carrying a coil
of hosepipe. He stops to look curiously at the two figures bent over the
hive.* PEPA *looks up, notices* LEANDRO *and waves. He returns the
greeting and walks off. Sound of a jet fighter in the sky.*

GARDENER: Every time one of their fucking F5s does that, I can't
　　help thinking of the day when it won't be just an exercise.
PEPA: Leandro's taking me to a dance tonight.
GARDENER: Where?
PEPA: Near the Castellana.
GARDENER: You'll lose your job if you're late every morning.
　　You'll be out of work. One of the millions. Look! Pepa!
　　Look! There's the queen!
　　(*Enter* ACTRESS, *accompanied by* DOCTOR.)
ACTRESS: (*To* DOCTOR) It's three years since I was here. I cannot
　　tell you how much she fascinates me, this woman. Perhaps I
　　should ask?
　　(ACTRESS *approaches very tentatively and cautiously (because of
　　her fear of bees)* GARDENER.)
　　I wonder if you could tell me – we're looking for the grave of
　　the Duchess of Alba.
　　(GARDENER *raises his masked head but appears not to have
　　understood.*)
GARDENER: In ten minutes the cemetery closes.
PEPA: You're on top of it. The Duchess of Alba's grave is the one

3

over there, the one where the stones have fallen.

(ACTRESS *and* DOCTOR *go to grave indicated backstage. They talk together, inaudible to us. Enter right* FEDERICO *and* TONIO, *two friends strolling through cemetery.* FEDERICO *wears a suit and carries a briefcase.* TONIO *is wearing jeans, canvas shoes and a white shirt.*)

FEDERICO: Anita used to bring me here when we were first going out together. Nothing's changed, it's so peaceful.

(*Re-enter* LEANDRO *who tentatively approaches the two men.*)

TONIO: I want to ask you a simple question. I see you so little these days. It's not a government secret.

LEANDRO: It can't be! Yet I know it is. It's him. Antonio Galvarez. I'd know him anywhere. Can I ask you, can I interrupt you for a second – could you give me your autograph?

(LEANDRO *offers* TONIO *an envelope.*)

The goal you saved in the last match against Lisbon, five minutes before the whistle . . . what a great save! Incredible!

TONIO: It's him you should ask for his autograph!

LEANDRO: Your friend?

TONIO: Yes. He's a minister in our government.

LEANDRO: I recognized you as soon as I saw you. It's Antonio Galvarez, I said. If it hadn't been for you we'd have lost against Lisbon! We all said the same . . . You were great. You had eyes in the palms of your hands. Could you sign on the back too? For my brother. Thank you.

(*Exit* LEANDRO. TONIO *and* FEDERICO *stroll on.*)

TONIO: Even in a cemetery they find me.

FEDERICO: Where more appropriate, my dear Tonio, than a cemetery? You're a popular hero!

(*Exit* FEDERICO *and* TONIO, *strolling, talking.*)

WIDOW: Grant him peace, O Lord, in thy mansions. Forgive him his sins, dear Lord, as I forgave him. He was short of breath and too fat, my poor Arturo. Coughed day and night. Yet he went on working to the end. Aceite de oliva, aceitunas, pimientos, cuanto señora? Ah yes! he said to the customers, if you want a healthy country, you have to look to the army! Punish him if you must, dear Lord, but only a little. He isn't

4

strong. Cut my toe-nails, Maria-Luisa, he used to say, I can't
reach them without you.

(DWARF *wakes up*.)

DWARF: Old lady takes a can
To water her flowers
Buried alive a man
Will die of thirst

WIDOW: In your merciful goodness, O Lord, do not forsake your
humble servant, Maria-Luisa, and her poor son Felipe today
in jug. For stealing cars, dear Lord, cars. Even when he was
a toddler he liked everything mechanical. I know it wasn't
him. It's the company he keeps. Let a little justice come to
this earth, dear Lord.

(DWARF *approaches* WIDOW.)

DWARF: Merciful señora, consider my poverty and let my
wretchedness be a test of your virtue. Of the three, said the
Lord, the first is charity.

WIDOW: God gave you a head, a pair of legs and a pair of arms.
And your arms he gave you to work with!

DWARF: The rise in the standard of living, merciful señora, is bad
for us beggars. The more people have, the less they give. But
you, señora, I can see in your eyes – you are like a mother.

(PEPA *walks from beehive to bell and rings it. Re-enter* TONIO
and FEDERICO. *Everybody, except* GARDENER *and* PEPA,
*slowly takes the path to cemetery gate, and exits. As they do so we
hear snatches of their conversation*.)

WIDOW: (*To herself*) Let a little justice come to this earth, dear
Lord.

DOCTOR: (*To* ACTRESS) You wanted to seduce your father so you
became an actress.

TONIO: (*To* FEDERICO) It's something I ask myself in planes
when I have to fly . . . Are our civil wars over? Are they
impossible now?

DWARF: (*To* WIDOW) We have only a short time to please the
living, all eternity to please the dead.

LEANDRO: (*Shouting to* PEPA) Wear your new white dress tonight!
(*When all have gone, another jet fighter crosses the sky*.)

GARDENER: They are filling the second honey box; it'll be a good

5

year, Pepa. Do you know how . . . ?

PEPA: Yes, Papa, I know. You tell me every July.

> (*Enter* LEANDRO *and* ACTRESS, *running from the direction of the cemetery gate. They are agitated.*)

LEANDRO: Not a drop of rain!

ACTRESS: I saw it but I don't know what it is!

LEANDRO: It goes as far as the horizon on every side.

ACTRESS:How can such a thing happen?

> (*Enter* WIDOW.)

WIDOW: It's the end of the world.

> (*Enter* FEDERICO *and* TONIO, *followed by* DOCTOR.)

FEDERICO: With a blue sky, without a sound, within half an hour.

ACTRESS: One of you, for Christ's sake, one of you tell me how such a thing can happen?

DOCTOR: In principle such a transformation takes several hundred millennia.

GARDENER: My God! They've done it! They've ruined the world.

> (GARDENER, WIDOW *and* TONIO *kneel.*)

FEDERICO: God won't help us.

GARDENER: There were so many warnings.

LEANDRO: I'm going to build us a raft.

> (*Enter* GOYA, *dressed in a frogman suit, from direction of cemetery gate. With his appearance the mood changes. He is dripping wet. Takes off mask. A man in his forties.*)

FEDERICO: Where have you come from?

GOYA: From Fuendetodos.

ACTRESS: Fuendetodos? On what planet is that?

GOYA: On this one.

ACTRESS: How did you manage to get here?

> (GOYA *mimes swimming.*)

TONIO: You're saying the water goes as far as Saragossa?

> (GOYA *nods.*)

FEDERICO: Salt?

> (GOYA *nods.*)

WIDOW: It's not possible. With the feet of the Devil himself, you couldn't have swum from Saragossa to Madrid! How many kilometres is it?

6

LEANDRO: Four hundred and twenty-seven. I've done it on my
 motor bike.
WIDOW: No!
DWARF: If he says he did, he did.
GOYA: I come here every evening. But for you, all of you, to be
 here together, I've waited a hundred and sixty years.
ACTRESS: That makes him a ghost!
DOCTOR: Collective hallucinations, my dear, are a phenomenon
 I've written a paper on.
ACTRESS: Who are you?
GOYA: I made a lot of money out of my heads. I was the father of
 many children, nineteen, twenty, I forget. And I was famous
 among the Cuadrillas.
WIDOW: God in heaven! It's him. My Chico. Only Chico could
 invent such stories. Nobody in Fuendetodos believed him.
GOYA: Nobody in Fuendetodos believed anything, madre.
ACTRESS: Are you her son? Is she really your mother?
WIDOW: How dare you suggest he's not my child!
GOYA: I'm her son, yes. And I'm your lover.
ACTRESS: How would you paint me?
GOYA: Lying on your back, legs crossed. Your eyes looking into
 mine.
ACTRESS: Dressed?
GOYA: For those who wish.
ACTRESS: Undressed! Coward.
GOYA: Get rid of her!
ACTRESS: It wasn't then that you said that!
GOYA: Sometimes I forget the order of things.
FEDERICO: You had a sense of timing, Francisco, like none of us.
 The moments burnt you or you burnt them. But you had no
 sense of history. You remember when I came to ask your
 help?
GOYA: How did I reply?
FEDERICO: You refused me and I spent years in jail.
GOYA: I don't remember.
TONIO: I never doubted for an instant you'd come in the end.
GOYA: I've come to see my mother.
TONIO: I thought your mother was dead.

7

GOYA: A mere detail.

PEPA: That's exactly what you said. In Saragossa. The year before I was born.

GOYA: I was very old when I met you.

PEPA: On Friday at 2 p.m. in the Place d'Aquitaine, there will be a public execution, French style.

GOYA: I shall be there.

PEPA: A poor wretch called Jean Bertain murdered his brother-in-law.

GOYA: So many murders . . . I remember nothing about Jean Bertain.

DOCTOR: I would like to ask you a medical question –

GOYA: No, I didn't have the clap.

DOCTOR: You often complained of a sense of water filling your head. A kind of aquaphobia. Your role as a frogman is perhaps a compensation.

GOYA: That's your business . . .

DOCTOR: My question is this: did your aquaphobia precede your deafness or follow it?

(GOYA *ignores the question.*)

GARDENER: (*Referring to* DOCTOR) It was he, Don Francisco, who stole your skull.

GOYA: I know, I know. What difference does it make, one skull more or less? I can live without a skull. I belong to the twentieth century, they say. I was born in the eighteenth. Everything is mixed . . . There's a child crying, I see soldiers raping a woman, I hear interrogations under torture . . . Two centuries ago a Dutchman painted a goldfinch. That's true isn't it, Pepa?

PEPA: For us it's four centuries ago today.

LEANDRO: (*Jealous*) Who is this man?

PEPA: Francisco de Goya y Lucientes.

GOYA: Francisco de Goya y Lucientes . . . What is it? I still don't know . . .

FEDERICO: OK, Paco, OK. I know your jokes by heart. You've trapped us here with your trick flood. But now let's come down to earth. Be reasonable. (*He looks at his watch.*) In exactly one hour I've a meeting with the Prime Minister.

8

Life must go on. It was a good joke, Paco . . .

GOYA: A good joke! What the hell! What the hell, my friends! All
my life, what the hell my loved ones, I was haunted . . .
Today you use my name whenever you want to say haunted,
whenever you want to say living in a hell. Goyaesque, my
arse! You live in your century and I'm in peace everlasting,
this is how you think. What the hell! I've trapped you here
this evening and I'm going to put you to work. The tables are
turned, tonight the tables are turned. You spectators are
going to make my portrait. You're going to begin
immediately. You're going to paint me with your lives.
Prime ministers or no prime ministers, dances or no dances.
You are going to do my portrait for me, painted with your
bodies and souls. So I can see myself at last and then die. So I
can forget Francisco de Goya y Lucientes for ever!

GARDENER: What colour ground shall I prepare for the canvas,
Don Francisco?

GOYA: White. Blinding white.

(*White curtain descends.*)

ACT ONE

SCENE I

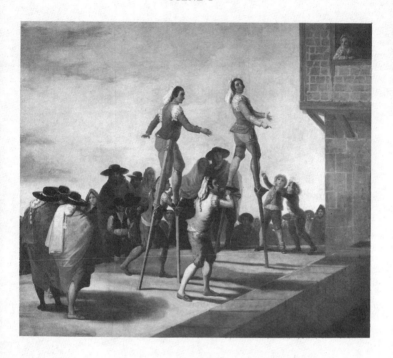

The stilt-walkers
(The Prado, Madrid)

Front of stage before semi-transparent curtain, through which cemetery is partially visible. Chair, dressing-table, open trunk of clothes. ACTRESS *is dressing and making up as* DUCHESS.

ACTRESS: I can't get him out of my head, he's there. Francisco de Goya y Lucientes. When I want to mock him I shall call him Frogman. How is it possible that I, Doña Cayetana, with my beauty, my taste, my name – can't get him out of my head? He pursues me as no man has ever done. When he leaves me, he stays there. He's small, short-legged, plump, getting on in age. Worst of all, he's married, father of God knows how many children. How is it possible? Anyway I intend to live either with or without him! And I'm going to show you all who the Duchess of Alba is!
(Curtain goes up to reveal autumn night. Garden of one of the Duchess of Alba's residences near Madrid. Chinese lanterns. The scene is basically that of the cemetery – as is the case throughout the entire play. Beside the ruined chapel a brand-new horse carriage with white wheels. An English phaeton. The DWARF, *dressed as the* bufón *(jester) of the Duchess's household, is standing near the carriage.* ACTRESS, *now* DUCHESS, *wanders across stage.)*
DUCHESS: En France, ils font la révolution. Il ne faut pas rater ça!
*(*DUCHESS *exits towards the house and the music.)*
DWARF: There's no country in the world funnier than ours. We have tribunals which hang twenty citizens a day and afterwards argue for twenty years about the best way of unharnessing a mule from a cart. *(He glances at carriage.)* Comedy is everywhere. As the great nation of conquistadors who converted the southern continent of America, the oceans are always with us. We have fifteen ships in the Royal Navy. And for these fifteen ships we have one Grand Admiral, two Admirals, twenty-nine Vice-Admirals, sixty-three Second Vice-Admirals and two hundred and fourteen ship's captains!

(*Enter* DUCHESS *holding a flaming torch, accompanied by*
DOCTOR, FEDERICO, GARDENER, TONIO. *All but* GARDENER
are dressed as courtiers.)
We are a nation of rags and uniforms.
(DWARF *opens carriage door.* GOYA (*in his mid-forties*),
elegantly dressed as court painter, steps out.)
This man paints the uniforms. The uniforms adore it.
(GOYA *crosses the stage to kiss* DUCHESS's *hand. She withdraws
it quickly, majestically, and advances to the footlights; the*
DOCTOR *following behind her. She addresses the public.*)

DUCHESS: The Jacobins are insisting upon a trial for Louis and
Marie-Antoinette. They will be executed . . . for us, with our
experience, this is a foregone conclusion. I too would like to
be executed. The head is severed and the name is
remembered for ever.

GOYA: Cayetana!

DUCHESS: I have not yet given the word. Monarchs order their
own executions, although to the ignorant it appears
otherwise. Tonight the Thirteenth Duchess of Alba has
come to a decision and you are assembled here to be the first
to hear it. (*Aside to* DOCTOR) Are you sure the servants are
ready? (*To public*) The century into which we were born is
waning to its close. The Royal Observatory is being built so
that men can look at the night sky through telescopes. A
woman has no need of a telescope. Doña Maria Teresa
Cayetana de Silva y Alvarez de Toledo can already see the
new century approaching. The nineteenth it will be called.
'The nineteenth century.' The sound is awkward. An
indivisible number. The twentieth sounds better.

DWARF: (*Tapping carriage*) Fucking Phaeton Silver Shadow!

DUCHESS: Perhaps in the twenty-second century, with a 2 beside
a 2, the impossible will become possible and we'll open like
flowers, again and again and again . . . (*To* DWARF) Would
you like to live, Amore, in a time when no flower ever fades?
(*To* DOCTOR) It's better that you go and supervise them. I
want the flames well timed.
(*Exit* DOCTOR.)
Tonight the Thirteenth Duchess of Alba has an

announcement to make to you. She is going to give
everything away. Everything she has inherited is to become
yours. This land, her forest, the game in the forests –
GOYA: She's out of her mind, game is for kings, not peasants.
DUCHESS: – her sheep and horses, her mills and fountains, her
presses and fruit trees, her vines and coach houses,
everything, her entire estate she is giving to you before you
suffer the shame of having to ask for it, before you become a
mob, unaware of what you're taking. Doña Maria Teresa
Cayetana de Silva y Alvarez de Toledo, Thirteenth Duchess
of Alba, offers to you herewith, her one-time servitors and
tenants, the patrimony of her family in Castile. Take it with
her blessing!
(*Enter* DOCTOR *hurriedly*.)
DOCTOR: (*Confidentially to* DUCHESS) The servants are refusing!
DUCHESS: Then whip them!
DOCTOR: I warned you they'd refuse.
FEDERICO: As if history was a child you could teach! (*To* GOYA)
Your Cayetana lives on another planet.
GOYA: I've been there!
DUCHESS: (*Turning to* DWARF) Amore, what would you like to see
burnt?
DWARF: The dresses of all the brides in the world!
DUCHESS: Why?
DWARF: So I can see what otherwise I'll never see.
DUCHESS: (*To public*) Guests, the Duchess of Alba demands one
last service of you. Come with her to set fire to her palace.
That all burn! Rooms, galleries, library, beds, tapestries,
portraits!
(GOYA *hurries out*.)
That all burn! Linen, velvets, brocades, lace, silks. All the
crap of this vanity of a life, let it burn! Chests, closets,
carriages, coffers. That all burn! And that we, watching, be
purified and proud of how we faced the end of our time
together!
(*Enter* GOYA *carrying a large framed portrait (we do not see the
painting), which he places carefully in his carriage*.)
Why is there no cheering?

TONIO: It's premature, Doña Cayetana, too soon.

DUCHESS: I want to see it burn.

TONIO: It can't happen yet.

DUCHESS: I will insist.

TONIO: If you insist, they will kill you first.

(*Enter* DOCTOR.)

DOCTOR: They're filling sacks with sand to put out any fire. They're carrying water on their heads from the well.

DUCHESS: (*To* TONIO) You, Don Antonio, who know so much, tell me why.

TONIO: The madness hasn't come from them.

DUCHESS: I'm giving them everything!

DWARF: It's Tuesday, Doña Cayetana, and on Tuesdays there's no more crime in Madrid. No thieving, no rape, no murder. Not even, Doña Cayetana, a single case of arson.

DUCHESS: I want to see it burn, Amore.

DWARF: Every Tuesday the Devil goes to Paris – to dine with Robespierre. Try it next on a Friday, Doña Cayetana, a Friday or a Monday.

(*Exit* DUCHESS, *accompanied by* DWARF, DOCTOR.)

GARDENER: (*To* GOYA) She's shrewd, your lady. She was testing public opinion, I could see; trying it on. Fortunately no one reacted. Fortunately we live in a time of peace.

FEDERICO: Peace! The Inquisition promises peace to the souls of the bodies they torture!

(FEDERICO *walks to sit on a tomb backstage.* GARDENER *crosses stage, opens door of carriage, takes out a pot of paint and brush and, sitting on the ground, starts to paint one of the white wheels white.* GOYA *addresses* TONIO.)

GOYA: (*Running his hand along the coachwork*) English. Shipped to Barcelona in pieces and assembled in Madrid. I paid eight thousand reales for it. He's my coachman. I brought him to Madrid. He was born in Fuendetodos like me. We grazed goats together. He understands horses and mules as well. Whilst Juan drives, I lie back on the upholstery, which smells of limes and sherry, and I gently lift the mantilla off her head.

TONIO: Cayetana's hair –

GOYA: 'The Duchess of Alba', Tonio, would sound better from your lips.

TONIO: You've no need to worry, Francisco, she doesn't take me seriously. She listens to my advice about certain things, but I count no more than Amore the Dwarf, or Rodriguez the Doctor or the violinist her husband. If I speak of what's in my heart, she mocks me: 'Who do you take me for, Don Antonio? A turtle dove? Consider me, my friend, with a different eye.' If I had a little of your genius, Francisco . . .

GOYA: Genius! God forbid! Genius is a calamity. A catastrophe. Something you fall into – like Paul on the road to Damascus. Brilliance! Skill! Cunning! Speed! They're words I like to hear and words I'm used to hearing. In any case she's right, she's no turtle dove. She flies by night and she keeps strange company.

(*Enter* DWARF, *who has been hiding behind a tree.*)

DWARF: A moth with white stockings and a ring on her finger inscribed with the letter – the letter F!

GOYA: One day they'll burn you, Amore.

DWARF: Show its pair! Show the ring on the middle finger of your left hand! (DWARF *tries to seize* GOYA's *hand.*)

GOYA: Do you want me to throw you over the cemetery wall?

(FEDERICO *approaches the others.*)

FEDERICO: The tension mounts! Do you never stop playing? And at your age, Francisco! I've something to tell you which is a little more prosaic. Agents of the Holy Office entered my house and searched my library yesterday morning. Tidy, systematic, correct. They took away 231 books. I counted those which were missing. It may have been 233. I'm assuming that two of the books were ones I lent to a student and I'm not sure whether he returned them. They also left me a warning.

GOYA: What did it say, the warning?

FEDERICO: *French science corrupts.* It's just the beginning. Luis de Samaniego has been arrested and flung into prison. Every scrap of news which comes from Paris means they'll pull the net tighter. Unhappily it's not the Duchess's theatre that'll save us. Are you driving back to the city tonight? Perhaps

17

you could take me?
(GOYA *opens door of carriage and bows.* FEDERICO, TONIO *and* GOYA *enter carriage and close door.* GARDENER *continues to paint wheel white. Lights fade, darkness.*)

ACT ONE

SCENE 2

The garter
(The Prado, Madrid)

Same as previous scene except that the Chinese lanterns have been extinguished. It is the middle of the night. Total silence. DWARF *with lantern is alone on stage.*

DWARF: Comedy everywhere, day and night. Our King is known as the He-Goat. He likes shooting partridges. So does Goya. They do it together. The difference between the He-Goat and Goya is that Goya is frightened of being cuckolded and the He-Goat doesn't mind. The Queen is called the Whore. She doesn't mind this, but if some unfortunate calls her the Toothless Whore, he or she is thrown into prison. A special branch of the Holy Office deals exclusively with this seditious nuance. The Prime Minister, who is the Whore's lover, is referred to throughout the land as the Blood Sausage. Somebody has arrived.

(DWARF *opens the carriage door and* GOYA, *wearing a hat with lit candles around the brim, gets out.* DUCHESS *enters, running, dressed in white.* DWARF *places lantern on ground and exits.*)

DUCHESS: There you are! Lit up! I scratched myself on the thorns running, in the dark. My foot touched a snake. I was waiting for you.

GOYA: For how many nights?

DUCHESS: Nobody asks me such a question. Your duty was to arrive.

GOYA: I'm here.

DUCHESS: What makes a man fight a duel?

GOYA: Honour.

DUCHESS: Foolish. Honour is nothing.

GOYA: If you were a man, you would never fight a duel?

DUCHESS: Perhaps.

GOYA: If not for honour, for what?

DUCHESS: So as to understand you . . . Approach you . . . Come closer to you.

(GOYA *places hat with candles on ground.*)

How are you going to come through the thicket of thorns?

GOYA: With my eyes open and my face unprotected.

DUCHESS: What will you do with Cleopatra's two asps?

GOYA: I will entwine them together to make a necklace for the Duchess of Alba.

DUCHESS: How far will you go?

GOYA: To the last stitch and the last wound.

(DUCHESS *pinches out candles.*)

DUCHESS: What will cure you?

GOYA: Your weight on my shoulders.

DUCHESS: Where will you carry me?

GOYA: To Fuendetodos.

(*Scarcely visible in the light of the lantern, the two figures approach the carriage. Lantern goes out. Total darkness.*)

DUCHESS: When I die, I will give you the flour of my bones, my Arab legs and my name for ever.

(*Noise of carriage door shutting. Violently all lights go full up. No one is to be seen inside the carriage or out. Even the lantern has disappeared.*)

ACT ONE

SCENE 3

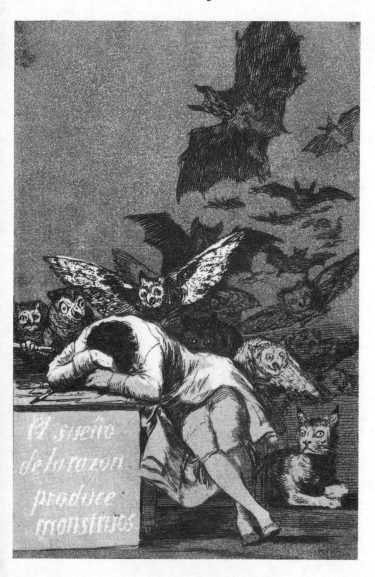

The Sleep of Reason Begets Monsters
(The British Museum)

*A few weeks later. Goya's house in Madrid. Front of stage before
semi-transparent curtain through which cemetery is dimly visible.*
FEDERICO *seated at table.* GOYA *standing, holding a handful of
papers.*

GOYA: I have too many commissions, there's the problem. I'm
 looking for a good assistant, can't find one. People don't
 know how to paint any more. Too stiff, no flexibility. You
 have to be like a brush to be a painter. Like a sable in the
 forest. Flexibility is all . . . think of José Garcia (*Imitates
 bullfighter*) – there's an artist.
FEDERICO: I've come to ask your help.
GOYA: How much do you need? Is it to pay the printers? There
 are men whose destiny is to owe money to poor printers all
 their lives. They are creatures who can't stop writing and
 who can't write what the authorities want! Isn't that so?
FEDERICO: No, this time it's not that.
GOYA: What have you written now? Another report on the state of
 our peasantry? The poverty of our villages? The reluctance
 with which we relinquish the dying? Ah, my dear Federico,
 in another life you'll have a great political following.
FEDERICO: In this one now I have some.
GOYA: I know, I know, you fight like a lion for justice, for the
 good of the people . . .
FEDERICO: I need your help.
GOYA: How many reales? I'm expecting a packet any day now. A
 commission from Her Majesty the Whore. She wanted the
 whole family done. All the royal meat, from the infantas to
 the ga-gas, shimmering pink through lace and silk. They
 were delighted. So was I. Yet how it hurts them to pay! It
 makes me laugh. Listen to this, an account from the King's
 Exchequer. 'Concerning your payment, we are, I take it, in
 agreement: six heads at 2000 reales apiece, and five heads at
 1000. As you will observe I have counted therein the head of

His Highness the Baby Prince. But, as I'm sure you will concur, heads number 12 and number 13 of the other royal children who were absent should not be included, any more than head number 14 which is a portrait of yourself . . .'

FEDERICO: Lending me money you risk nothing.

GOYA: No need to reassure me.

FEDERICO: What I have come to ask you does involve a risk.

GOYA: You want me to paint you something in secret, something it would be unwise to show to others? You're not the first, my friend, and I'm an expert. Discreet, skilful, subtle. I have several secret pictures of my own. We live in such times. Nobody has seen them. Nobody will find them. Tell me what the subject is?

FEDERICO: Neither money nor paintings, Francisco. For once it concerns flesh and blood. And a brain. A brain they want to stop working. I need to hide for a few days.

GOYA: Where?

FEDERICO: Here in your house.

GOYA: When?

FEDERICO: Now. They're searching for me.

GOYA: The Holy Office?

FEDERICO: Yes, the Inquisition.

GOYA: Too many people come to this house. It would be dangerous.

FEDERICO: For a few days where you hide your secret pictures . . . Time to let Romero spread the rumour I've left for Lisbon. Then we'll arrange that 'somebody' see me in Lisbon.

GOYA: If I didn't have an official position . . .

FEDERICO: A few months ago we all had official positions –

GOYA: An official position in the King's Household.

FEDERICO: We're losing them one by one. Luis de Samaniego has been tortured. Since then, no news. Silence.

GOYA: Our crime? What is it? We believe in Reason. We believe Reason is given to man.

FEDERICO: They believe in the garrote and the sambenito.

GOYA: Better to die than the sambenito.

FEDERICO: Jovellanos and Saavedra have been forced into exile.

GOYA: Are they already investigating me? Do you suppose I'm being watched?

FEDERICO: Luis de Samaniego taught mathematics in the University of Salamanca. No less innocent than painting canvases, at first glance, no less innocent.

GOYA: Take the carriage. Let me offer you my carriage. With it you can make your getaway.

FEDERICO: Like carriage – like man!

GOYA: What do you mean?

FEDERICO: Both are too conspicuous. No, don't protest. I haven't a minute to lose. I've lost time here already.

(FEDERICO *grasps* GOYA's *arm and walks swiftly off. Stops and turns round at last moment.*)

I've never presumed to give you advice about your art, but since we may not see each other for a long time, remember what I say now. You must use another medium. Less conspicuous. Easier to hide. Unofficial. With which one can make several copies in case some are lost. For some are always lost. Adieu, Francisco.

ACT ONE

SCENE 4

Sketch of nude
(The Prado, Madrid)

Day. Spring (1794). Duchess's residence. To right of chapel a bed
with muslin hangings. DUCHESS *bent over bed murmuring.*
GARDENER *painting wheel of carriage.* GOYA *opens carriage door,*
climbs down. GARDENER *stops painting. Both men watch* DUCHESS
who continues her ministrations to sick child in bed.

DUCHESS: Going away, going away, soon there'll be no pain left,
 I'll take it all away. Don't fret, give it to me, little one . . .
GARDENER: If she had a child of her own – the Duke, they say, is
 not a breeding animal.
DUCHESS: Sip, darling, from the lemons of our very own garden.
GOYA: Nobody on earth should be allowed to have a voice like
 hers.
DUCHESS: Did you dream the world was bad? No, no, only theirs,
 not ours. It's cooling – if I press it against you – see – it cools,
 it cools my honey.
GOYA: It's so beautiful, it cuts your throat from ear to ear, a voice
 like hers.
DUCHESS: There, the hurt is coming, come to me, come to me,
 we'll mend everything, feather by feather . . . come, little
 pain, come to Cayetana, come, little death.
GOYA: My mother used to say death was a feather.
GARDENER: Your mother, Don Francisco, is a woman who
 weighs her words.
DUCHESS: Don't come too close, both of you. Not too close. His
 eyes are closed.
GARDENER: The swallowing disease?
DUCHESS: Peace.
GOYA: Scarlet fever?
GARDENER: The illness of the marshes?
GOYA: Typhoid?
 (DWARF *leaps up, tears down hangings and jumps out of bed.*)
DWARF: Growing pains!
 (GOYA, *seized with a fit of rage, swears at the* GARDENER.)

DUCHESS: Why are you so angry? Come and sit beside me. Let us say good day to each other. Good day, Frogman.

GOYA: How does your husband put up with that creature?

DUCHESS: My husband puts up with nothing. He plays Haydn.

GOYA: And I put up with everything.

DUCHESS: Don't you think others have the right to play jokes? Does every caprice have to be signed by the master on a plate?

GARDENER: My God! Do you hear what she says! You've shown her, haven't you? You've shown her. How many times have I told you to show nobody? It's dangerous for nineteen reasons.

DUCHESS: Baturros! Baturros! You don't know how to live. Neither of you even knows the difference between a coachman and master. Listen how he talks to you.

GOYA: (*To* GARDENER) She has only seen one or two donkeys.

GARDENER: And the donkey is who? Twenty reasons. Have you ever heard anybody ever stop talking here? Never. Prattle! The Devil needs nothing more.

DUCHESS: And in Aragon, sir?

GARDENER: In Aragon, Your Duchess, men measure their words, use them sparingly and keep them.

(GOYA *makes friendly sign to* GARDENER, *who returns to carriage, picks up paint pot, gets in, shuts door.*)

DUCHESS: Are you still angry? I have arranged something special for you.

GOYA: More theatre with the Dwarf?

DUCHESS: Do you know why I call him Amore?

GOYA: I killed a man once.

DUCHESS: I've never met a man who hasn't boasted of killing another. Even my husband says he killed a man . . . a flautist it seems. No more need for anger. I want to show you something.

(GARDENER *pulls down blind of carriage window.* DUCHESS *enters the ruined chapel, followed by* GOYA. *Silence. We do not see the painting they are looking at.*)

DUCHESS: I acquired it at the age of thirteen when I got married.

GOYA: He was impervious. He judged nothing. He kept his

eternal distance. Only his glance caresses her.

DUCHESS: His glance! What does his glance matter? There's a
woman there, lying on a bed, naked. I watch her every night
after my prayers. It's she who counts.

GOYA: For very little, she counts for very little. Look at the
draperies which echo and enclose her body. He knew exactly
what he was doing.

DUCHESS: She counts for very little! Your impudence! You peer
at us, you get a cunning kick out of pinning us with your
brushes to your sheets, your canvases and then you boast: He
knew exactly what he was doing! You know nothing. Men
see only surfaces, only appearances. Incorrigibly stiff,
incorrigibly rigid, the lot of you! Male monuments to your
everlasting erections!

GOYA: I could do better.

DUCHESS: I could do better! Nothing else matters. Maria Teresa
Cayetana de Silva y Alvarez de Toledo has shown her
Velázquez, the only naked woman reclining on a bed painted
in the long history of Spanish art, to her lover who is a
painter and what does he say: 'I could do better.'

GOYA: I could do better.

DUCHESS: How would you paint me?

GOYA: Lying on your back, legs crossed. Your eyes looking into
mine.

DUCHESS: Dressed?

GOYA: For those who wish.

DUCHESS: Undressed! Coward!

GOYA: First dressed!

DUCHESS: What patience! What restraint.

GOYA: Next, in the twinkling of an eye, undressed.

DUCHESS: With my consent.

GOYA: With your consent, Cayetana, or without it. I can tear off
your clothes. I can strip you as well as I can paint you. Here!
(*He points to his head.*) That's where I have an edge over
Velázquez. No mirrors. I advance on my stomach. Mix my
colours with spunk.

DUCHESS: Your colours, sir, are your business. It will be done
from memory. You will paint me when you are alone. You

33

will remember all the women you have known, all the
women you have stripped – as you so eloquently put it – you
will close your eyes and see them again and then you will use
all your effort, all your virility, all your speed to recall what
distinguishes every square centimetre of the body of the
Thirteenth Duchess of Alba from the body of any other
woman now or hereafter. From memory. It will be a solitary
proof of your love . . . Afterwards I promise you a month in
the country . . . the two of us together.

(GARDENER *climbs out of carriage, starts painting wheel.* GOYA
crosses stage.)

GOYA: More and more and more and more . . . brazen!

(GOYA *enters carriage.* DUCHESS *waves a handkerchief.*)

DUCHESS: Work fast, Frogman.

(*Lights fade.*)

ACT ONE

SCENE 5

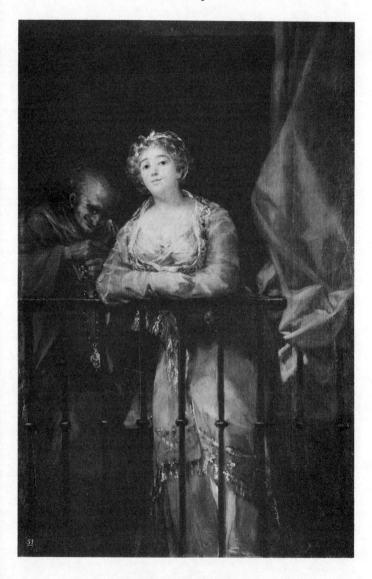

Maja and Celeste on balcony
(Private collection, Madrid)

Summer evening (1794). An inn in the countryside. Table and chairs.
PEPA, *dressed as a servant, is slumped in a chair, idle. Voice of*
GARDENER *offstage.*

GARDENER: If we drive any further in this shit, it'll be up to the
 axles. With your lady nothing is simple, Francisco, nothing.
 (*From behind the chapel appears an enormous bouquet of roses –
 as if advancing by itself.* PEPA *stares, mesmerized.* GARDENER,
 *hidden by the flowers he is carrying, picks his way forward,
 followed by* GOYA *carrying a chest.*)
 We want a room with a window that looks out on to a
 pomegranate tree.
 (PEPA *does not react.*)
GOYA: You have a room on the first floor with a balcony. Almost
 touching the balcony is a pomegranate tree. That is the room
 I want.
PEPA: The third room, yes, with a pomegranate tree outside. It's
 always the first choice. You're lucky, for no one else has
 come tonight.
 (GOYA *opens the chest, and takes out some embroidered silk.*)
GOYA: Hang this by the window – a little to the side, so. These
 pillows (*Takes out lace pillows.*) for the bed. And be quick
 about it.
PEPA: What are we going to do with the flowers? There are not
 enough vases in the whole inn.
GARDENER: Then wet a sheet and give me that.
PEPA: I'll ask Uncle.
 (*Exit* PEPA.)
GARDENER: If her taste for roses doesn't slow down, we're going
 to need a dozen more gardens.
GOYA: Do I owe you money?
GARDENER: Money . . . money. You're ruining yourself,
 Francisco. You're heading for catastrophe. It's costing too
 much this passion of yours. It's not like your Phaeton. You

37

buy a Phaeton and it's yours, for good. With her . . . Soon
there will be no more heads left for you to paint. Do you
realize that? Everybody who can afford it will have been
painted by you.

GOYA: You'll see, Juan. From now on I'm going to paint only
roses.

(*Enter* PEPA *with two massive oil jars.*)

PEPA: My uncle suggested these . . .

GOYA: Perfect. You arrange the flowers, Juan. We haven't time to
waste. Bring some fruit – peaches, melons – and some wine.
Black.

PEPA: Nothing more to eat?

GOYA: She eats nothing. She has the appetite of a small bird.

GARDENER: (*To himself*) Birds eat continually. They never stop.
She's devouring him to the last morsel.

PEPA: (*To* GARDENER) And for you, sir? You look as if a plate of
potatoes and bacon would go down well.

GOYA: No time for eating.

PEPA: You are all the same when you make your rendezvous here.
Not a moment to be lost! She's coming! She's coming! And
the moments go by . . . and the hours . . . she's never in a
hurry. The other day there was a gentleman – come to think
of it he also asked for the room with the pomegranate tree –
he comes for a night, and he stays for a week waiting.

GOYA: Who was he?

PEPA: A student from Madrid, nice looking, much younger than
you, slim, with curly hair.

GOYA: What happened?

PEPA: He arrives and he says he's waiting for his *maja*. He shuts
himself up in his room. Nobody comes. A whole day passes.
Two days pass. There's not a sign of life out of him, or on the
road. I start to worry. Is he dead? I ask myself as I go up to
his room. He's not dead but he wishes he were! I get him
something to eat and whilst he eats he tells me his story. In a
tavern near the Castellana he meets a young woman with
long black hair down to her waist and eyes like coals and they
dance all night. When it's time for her to go she says to him:
'Go on Thursday to Fuencarral. Near the wood you'll find an

38

inn. There you ask for the room which gives on to the
pomegranate tree and you wait for me there.'

GOYA: Did he tell you her name?

PEPA: I think he said Teresa.

GOYA: And afterwards? Did she come?

PEPA: No.

GARDENER: I can think of another Teresa who might well play
the same game. She too likes dressing up as a *maja* and
dancing in taverns. We've seen it with our own eyes, haven't
we?

GOYA: Shut your mouth.

PEPA: The poor boy waited a whole week. He couldn't believe she
wouldn't come. He made up excuse after excuse for her.

GARDENER: They all do.

PEPA: At the end my uncle asked him to pay and he didn't have
enough money. So he left his pistol as a forfeit. A beautiful
pistol, I can show it to you, made in Cordoba.

GARDENER: At least he didn't kill himself with it!

GOYA: Shut your mouth! A question, my girl, is the room always
called 'the room of the pomegranate tree'?

LEANDRO: (*Offstage*) Pepa!

(*Enter* LEANDRO *carrying loaves of bread, his apron covered
with flour.* PEPA *runs away from the table to join* LEANDRO.)

PEPA: Leandro! At last!

LEANDRO: I couldn't come yesterday. Had to help Father repair
the cart. (*He notices the mass of flowers.*) It's not true! Who's
died? I've never seen so many flowers.

PEPA: They're roses, Leandro. The stout gentleman brought
them. He has a rendezvous here. She hasn't come yet, he's
waiting for her.

GOYA: (*Shouting*) Listen, my girl, can you reply to my question?
When your young man asked for the room did he say: 'I want
the room with a window that looks out on to a pomegranate
tree?'

(PEPA *walks back to the table.*)

PEPA: Our third room it is, like I told you, always our favourite
. . . I don't understand what you're getting at, sir. Yes, he
said: 'Is there a room that looks out on to a pomegranate

tree?' But he was a poet. After he left when I was cleaning, I found some papers under his bed and on them were poems he'd begun to write.

GOYA: Poems!

PEPA: My uncle read one out loud. The poet compared her body to the stem of an autumn crocus, so fine it was, and so white.

GOYA: Crocus! And a brothel with a pomegranate tree! It was her! I can recognize her anywhere with my eyes shut. It was her! We're leaving. We're not waiting.

(*Exit* GOYA *and* GARDENER.)

LEANDRO: I want the truth, Pepa. Those flowers and that chest of frippery, he brought them for you. Otherwise he wouldn't leave them behind, would he? I arrive unexpectedly, so he beats a retreat.

PEPA: It's foolish to be so jealous, Leandro. They weren't for me. (*Unnoticed by the others, the* DUCHESS *arrives from behind the chapel. She is wearing a white dress, her hair down to her waist. She stares at the flowers. Leans against the wall, closes her eyes, immobile.*)

LEANDRO: You're hiding something from me.

PEPA: Nothing, my hawk, nothing. It's a story I don't understand either. Don't fret, my love. They live their lives their way. Kiss me instead.

(LEANDRO *and* PEPA *embrace. Lights fade.*)

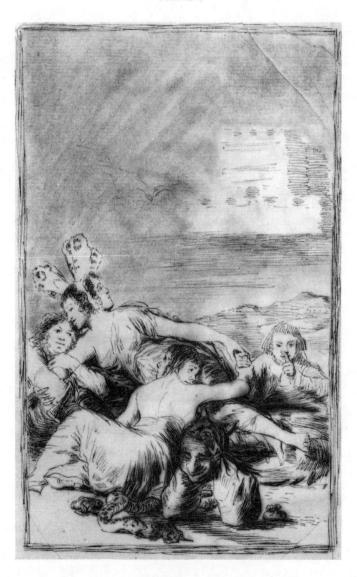

Sueño de la mentira
(drawing for Los Caprichos, The Prado, Madrid)

Autumn afternoon (1794). Garden of Duchess's residence. (There is no carriage.) A very low hammock hangs where, in scene 4, the child's bed stood. In it reclines DUCHESS. GOYA *lies on ground beside her, gently swinging hammock.* DUCHESS *is singing a kind of lullaby.*

DUCHESS: Seigneur saves his honour
 Rides away proud.
 The mad in the tower
 Are laughing out loud.

GOYA: What do we do when we're alone together?

DUCHESS: Everyone knows. It's proverbial.

GOYA: Say it. I want to hear your voice saying the words.

DUCHESS: Saying what everyone knows –

GOYA: Everyone is wrong. For we are never alone together! That's the truth. A month in the country. Those were your words, and in no time you forget! Take me to Fuencarral – I've never been there . . . Those were your words – words out of your own mouth.

DUCHESS: I fancy, inquisitor, the interrogation should now come to an end.
 (*Sings:*) The mad in their tower
 Are laughing out loud.

GOYA: What you offer, you take away.

DUCHESS: Then take all.

GOYA: In your lying hammock there's only place for one.

DUCHESS: Upset me then! Capsize your duchess. And we'll make love come down . . .
 (*Enter* WIDOW *dressed as dueña of Duchess's household.*)
 . . . down among the tombs! Capsize me!

WIDOW: A day of omens, Doña Cayetana, a day of undeniable omens. Last night the full moon, and not any one as you might imagine, but the hunter's full moon, as pregnant as our cook Lola. At dawn you woke up with both sheets fallen down on the Toledo tiles, even the one you were lying on. At

43

midday a swarm of bees in the plum tree. And now who should come but Don Antonio!

DUCHESS: You confuse everything. Don Antonio's coming is always good news.

WIDOW: More, he has not come empty-handed, and what he has brought to show us is something neither your eyes nor mine have ever looked upon.

GOYA: (*To* DUCHESS) Get rid of her!

DUCHESS: I want to look at what Don Antonio has brought for me.

(WIDOW *beckons* TONIO *who enters holding his hands over his shirt.* DWARF *and* DOCTOR *follow. Distant sound of music. Everyone gathers round* TONIO *to look at what he is carrying in his shirt.*)

TONIO: I found her in the Guadarrama a month ago. She's almost tame now.

DWARF: Pity the rabbits! She hypnotizes them with her gaze. And eats them for dinner.

TONIO: Didn't Raphael paint one, Francisco?

GOYA: Raphael was a fornicator.

DWARF: In the winter she wears white. Except for the tip of her tail which is black.

DUCHESS: Her coat is softer than a baby's hair.

GOYA: It was Leonardo. Except it wasn't a little brute like this, it was an ermine.

DUCHESS: How did you capture her?

DWARF: (*Singing*) Elle court, elle court, messieurs
 Elle est passée par ici
 Elle repassera par là.

TONIO: I found her on the grass by the edge of the Madrid – Salamanca autoroute.

DOCTOR: The ancient Greek name for the species is *Galata*. Which today is also the name of a district in Istanbul.

GOYA: They talk, they talk . . .

DUCHESS: Look at her eyes!

DWARF: Elle court, elle court, messieurs!

DUCHESS: Look at her eyes. Nothing deceives her. She knows what she wants. Why don't you call her Cayetana?

44

TONIO: Cayetana it is!

DUCHESS: Will the name Cayetana put a rabbit to sleep?

(DUCHESS *approaches* DWARF, *who pretends to fall asleep.*)

WIDOW: Do you know what the midwives say? They say this creature conceives by way of the ear and gives birth by way of the mouth.

GOYA: Everything said in this bog is mad. It begins in the house and it goes on in the garden.

DUCHESS: To conceive by the ear! There's an idea of genius. Pure genius.

DOCTOR: Here we should note, my dear, the constant ambiguity which touches everything concerning the ear as a symbolic organ: an organ which lends itself to both sensual and spiritual raptures. The male word enters the ear just as sperm enters the vagina to make its spiral way to the uterus and there to fertilize the ovule. Seminal fluid and Divine Words are interchangeable. The Annunciation is a perfect example of this ambivalence.

DUCHESS: What a mind you have, Doctor! Your ideas show us how to fly! Poets, philosophers, musicians all conceiving in the way you describe. You've turned my head. Engender, engender! Play for me.

(*Music begins. Suddenly* GOYA *charges the dancers and one by one, chases them offstage.*)

GOYA: Out, black! Out, seersucker! Out, little cleavage! Out, hosiery! Out, blood! I'll thrash you like wheat!

(EXIT *all except* DUCHESS.)

So quickly fled! Alone with my own voice now. Silence. Come brother voice and show your mettle. Cayetana! Cayetana, who gives birth and kills through her teeth! Cayetana the witch!

DUCHESS: How dare you! Those people belong to my household. Go back to where you came from, go home to your twenty children you spawn like a frog – go back to your long-suffering wife.

GOYA: When you look in the mirror, do you see your lies? Do you tie them under your chin and press them against your eyes so you can't hear the truth?

DUCHESS: Shouting can't frighten me. Do you really believe, you little mule from Aragon, that I've inherited none of the courage of my forebears? Do you think you can shout words at me like you throw stones at a bitch in your backyard?

GOYA: Easier to cover her nakedness with a scrap of flannelette than to hide her lies. Her lies are too long to cover . . . too sinuous. And they bleed too much, they leave stains on the Toledo tiles.

(*Re-enter* DOCTOR, *unnoticed by others.*)

DUCHESS: Silence!

GOYA: We, who are born in the dust, know better how to lie. We make good liars. We also know how to boast. This baturro standing here, was born a goatherd. He painted the finest cupola in Saragossa. He was appointed Artist of the King's Household. He decorated outrageously the church of San Antonio de la Florida. And he lays the Thirteenth Duchess of Alba!

DUCHESS: You mix the gossip of washerwomen with the vanity of a peacock.

GOYA: Paint me in black, she says. I don't paint in black, lady, I paint in muck. I paint you all in muck – with your ribbons and lace and organdie and gold. You marvel and you thank me, because you think, with my slime and my smearing, I've confessed you! The priests listen to your sins and give you absolution. I listen to what you look like, and you go away, all of you, believing your appearances have been forgiven.

DUCHESS: Turn your back. Your jealousy is too ugly.

DOCTOR: He's demented.

DUCHESS: Nobody on this earth has the right to tell me how to treat my guests, or how to spend my time. If I choose to dance, Frogman, I will dance, alone or in company, with or without music. You paint in shit, you confess us and what do you understand? Nothing. Don't you realize there are not many afternoons for dancing left? Don't you know there are no more nights than there are afternoons? Except the last one, Paco, the night which puts an end to all afternoons!

GOYA: She flies by night and she lays her breasts on the hands of the first comer.

46

DOCTOR: A brainstorm's burning out the cochlea nerve!

DUCHESS: What do you want with our two lives? Answer me! It's an order. Our so poor mortality. What do you want, Paco? Tell me and I'll listen.

GOYA: (*Taking his head between his hands*) In this boulder there's so much water, strike it, strike it like Abraham struck the rock! There's enough water between these ears, Cayetana, to quench the thirst of all your Father's horses. Strike it!

DUCHESS: Come. We'll whisper to each other. Quietly. Alone. (*To* DOCTOR) I want you to leave us alone. I want to be alone with my bull.

DOCTOR: (*Leaving*) Auditory perception now nil.

DUCHESS: (*Leading* GOYA *to hammock*) Just the two of us. I'll tell you what's never been told, what I've never even told to myself. When the Duke of Alba plays his everlasting music, I dream. And what do I dream of? I dream of you when you are roused, when you are man as I've never known man before. I want to be nothing but your covering. Throw me your dust. You who are man as Cayetana will never know another. What will you throw at me, my love? A knife here (*Her heart*)? It is yours already. A river to drown in? I am drowned. What will you throw at me? Throw me your dust, my bull. Say something. Say my name. Scream it if you want. Name me another name then . . . What do you want to call me?

GOYA: I can't hear you!

DUCHESS: Scream it if you want to!

GOYA: What are you saying?

DUCHESS: My love, my love! Anything!

GOYA: So quickly fled – all, all to the last word.

DUCHESS: Speak to me! (*She shouts louder and louder.*)
Paco! Paco! Paco! (*Duchess throws herself on her knees, clutching at the hammock which swings. Goya stands immobile.*)
 The mad in their tower
 Are laughing out loud!
(*Enter* DWARF.)

DUCHESS: He can hear nothing, nothing, *nada*. I've made him go deaf.

We must never leave him, never . . . Promise me, Amore?
(*Sound of jet fighter. Lights fade.*)

ACT TWO

SCENE I

The dog
(The Prado, Madrid)

Front of stage before semi-transparent curtain – through which is visible cemetery transformed into a landscape of boulders. Enter DWARF, *still dressed as in Act One, rolling a white carriage wheel as a hoop.*

DWARF: I told you we might all die of laughter – anyway we are dying. The Duchess of Alba died of food poisoning. Our country made war on France to save the principle of monarchy. There are flies everywhere this summer. We made peace with France to save ourselves. Then the *gavachos* kidnapped the He-Goat, the Whore and the Blood Sausage and are keeping them as hostages in Bayonne. More flies, more vultures than anybody can remember. Napoleon sat his brother Joseph on our throne and sent in his army to liberate us, to help us throw off the shackles of the past. His soldiers threw our women on their backs. Some are collaborating with the French to the death so Spain can become a modern country – with fewer rags and fewer uniforms. Some are fighting the French to the death, because they'll give their lives to keep Spain as it is. 'Who liberates who from what?' is one of history's worst jokes. The Year of the Blind, it's called, the Year of Our Lord, 1808. There's very little to eat. The rich still have their hair done. It's stifling hot. I've kept my promise to the Duchess and I've stayed with her painter. We're going to Aragon.
 (DWARF *swats fly and rolls his hoop offstage. Transparent curtain rises to disclose landscape of boulders. The colour of rust. Enter* GOYA *and* DWARF *in dark tattered clothes.* GOYA *is now aged sixty. When he speaks, the* DWARF *has often to shout or repeat his words, for his companion is deaf.*)
GOYA: (*Pointing*) At the foot of that rock, there's a dog howling.
DWARF: Let's both sit on it. We need a rest.
 (*They sit.*)
GOYA: Look between my legs! There's a town there. Where your

51

foot's dangling, the dog's howling.

DWARF: If you say so. What town is it, Don Francisco? WHAT TOWN?

GOYA: Saragossa.

DWARF: The town we're going to?

GOYA: All rocks are prophetic. What can you see, Amore?

DWARF: Figures running away in panic. What fire leaves behind. Smoke. A man on his knees, face upturned towards us, face that his mother put against her breast, cut like meat into suffering. If I was a man, I'd kill him out of pity. Behind him, a gulley, with corpses, some with French boots, some with shoes made of serge . . . Who built this town? WHO IS THERE?

GOYA: The giants. How do you know, Amore, you're not imagining everything you're telling me?

DWARF: I can't be. I have a cheerful imagination. As soon as I imagine, it's a joke! Do you like chicken? If it's cooked, yes. Do you like mule? If it's smoked, yes. Do you like fish? If it's dried, yes. Do you like milk? If she unbuttons her blouse, please! I never imagine anything as bad as life.

GOYA: I have no imagination. None at all.

DWARF: They say you are a visionary.

GOYA: I put down what I see.

DWARF: I've heard it said that in what you put down you exaggerate!

GOYA: What?

DWARF: EXAGGERATE.

GOYA: Blind fools! Appearances tell all. There's nothing they can't tell. Fools! There's no exaggeration that goes further than them. God, Amore, has left us alone with the visible, like deserting us in hell. He, the seer, is invisible. We with our flesh and hair, mucus and bones, are condemned to be seen. And worse than that, we are condemned to face what we see.

DWARF: Why don't you shut your eyes?

GOYA: When somebody's dead, you can see it from two hundred yards away, their silhouette goes cold.

DWARF: Let's think about the chicken all golden in the oven.

GOYA: It's full of fossils, that rock. If I say it is bleeding, do I
 exaggerate?
DWARF: (*Nodding*) You do.
GOYA: Correct. If I say we can shelter behind it, am I
 exaggerating?
DWARF: (*Shaking his head*) No.
GOYA: There are men whose faces are the most indecent parts of
 their whole bodies, and it would be a good thing if they put
 their faces in their breeches.
DWARF: Have you seen these men?
GOYA: I can't hear you. You shout, you make faces and I can't
 hear you! In Saragossa God is going to leave us.
 (*Sound of jet fighter. Lights dim.*)

ACT TWO

SCENE 2

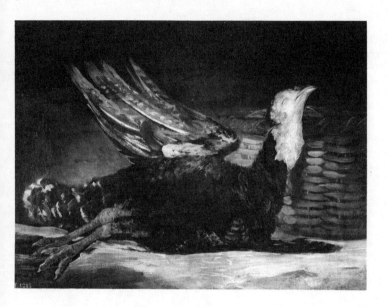

Dead bird
(The Prado, Madrid)

*Cemetery transformed into ruins of Saragossa. August 1808. The
deserted chapel is a ruined room in the city under siege. There are sacks
of wool, sandbags. GOYA is seated at a table, looking at a sketchbook.
From time to time there is the smoke and dust of explosions, distant
and near. The silence is total.*

GOYA: (*To audience*) You can't hear anything, can you? You're
 like me. You've switched off the sound. The image is grainy,
 but it's live. Did you see the wall of the house back there
 disintegrating slowly without a sound? Sickeningly slowly.
 Falling. Did you see the people being buried underneath the
 rubble without a scream? No sound. Bombardments don't
 stop at night, and it's not yet night.
 (GOYA *looks through broken window on to cemetery. Enter*
 DWARF, *dressed in tattered, dust-covered uniform.*)
 Amore's back. Up to God knows what.
 (DWARF *climbs on to a pile of rubble and pretends to read a
 proclamation.*)
DWARF: Heroic people of Saragossa, city of two cathedrals, take
 heed and listen, for it is your very own General Don José
 Palafox who speaks to you.
 (*Noise like a loudspeaker being adjusted.*)
 Women of Saragossa, you who have shown yourselves
 willing to sacrifice body and soul for the defence of our city,
 you whose fighting example has been an inspiration to every
 one of us, pick up now your spades and your shovels and
 your brooms, clear the streets, fill the sandbags, fortify our
 city. The French army will die of mortification knowing it
 has been vanquished by you; our mothers, our sisters, our
 wives, our fiancées. I am your father, women of Saragossa!
 (*Aside*) He's just turned twenty-eight our young Palafox . . . I
 am your father! Death to the Invader!
 (*Exit* DWARF.)
GOYA: During bombardments as many die in the dark as in the

57

light, perhaps more, because rescue work is harder – unless enough fires have been started, and the fires turn night into day. (*He turns a page of the sketchbook on the table.*) Palafox is a fool. Don José Palafox. No brains. I've studied him. Look at his mug. It's the face of a handsome bison. He looks better when mounted . . . which is why Her Highness the Whore gave him the second command of her Palace Guard. (*He closes book.*) One fire leads to another. I see a firestorm silently devouring a whole city in one night – flames, wind, a pillar of smoke, no explosion. Only ashes. The city is on a river like this one. The river Ebre and the river Elbe. I see an unborn soldier, who is not yet a foetus, lecturing on the military use of firestorms. His listeners are moths. Shh! I can hear their wings.

(*Enter* TONIO, *fifty, dressed like an irregular soldier, walking with great difficulty, one leg wrapped in dirty cloth. He embraces* GOYA.)

TONIO: At last you're here. I never doubted for an instant you'd come in the end.

GOYA: By mule Fuendetodos is half a day's journey. I was born in Fuendetodos. I've come to see my mother.

TONIO: I thought your mother was dead.

GOYA: A mere detail – what's happened to your leg?

TONIO: Masonry from a wall fell on my foot. You could see nothing for dust. I felt nothing at the time. We were charging a cannon under heavy mortar fire. We protect our heads with wool sacks. (*Smiling,* TONIO *picks up a sack and places it on his head.*) The whole world is watching us. The victors of Marengo and Austerlitz and Ulm shall not pass! The most powerful military machine in the world cannot quench our resistance. And why? Because they are lost. They have only maps. And the ruins are still our home. Have you seen our women? What have you seen?

GOYA: Was it a twenty-four-pound cannon?

TONIO: (*Nodding*) Yes.

GOYA: With iron wheels?

TONIO: Yes. Agostina – like a flower of flame. She seized a fuse from the hands of a dying artilleryman and fired a round of

58

canister point-blank at the *gavachos*. They fell back. They
couldn't advance.

GOYA: I can see you're feverish, Tonio. Come and sit. How much
longer can you hold out?

TONIO: Only you could ask such a question. It's like asking God:
How long will I live?

GOYA: How long?

(TONIO *makes the sign of 50 with his fingers.*)

Fifty! Fifty hours?

TONIO: Not hours! Weeks. I'm a member of the Junta. With Tio
Jorge, the water carrier, with Dom Basilio Bogueiro de
Santiago, scholar and strategist, with Pedro . . . How did you
get here? It's a miracle. God himself must have brought you.

GOYA: Who?

TONIO: GOD.

GOYA: Do you think God comes to places like this?

TONIO: God's love is so large it seems indifference. You shouldn't
go out when they are shelling.

(*Dust and smoke. No sound.*)

GOYA: The giants protect me.

TONIO: There are drawings in your notebook?

GOYA: The giants have no memory.

TONIO: When they bombarded the hospital, it was she who
organized the evacuation of the sick.

GOYA: Who did you say?

TONIO: The Countess Burita. She has a strange power. I was
there when the asylum was bombed. I saw what she could do
with the mad. THE MAD.

GOYA: The mad are innocent – even the raving ones they shut in
cages suspended from the ceiling, even they are innocent.
The truly rabidly mad are not shut up. Never. They are out
there at liberty – pursuing their madness. Every century,
pursuing it.

TONIO: She saved their lives.

GOYA: There was an innocent madman praying at the foot of the
Cross in the Coso. He said he was the river Ebre and he was
going to extinguish, with his waters, every fire in the city.

TONIO: It's six years since she died, isn't it?

GOYA: I saw another one wearing a loincloth – he was walking where the shells were falling like rain, and he was eating his own fingers.

TONIO: It's six years since Cayetana died, isn't it?

GOYA: Tonio, don't shout, please don't shout each time you mention her name.

(*An inaudible explosion very near the room. Dust falls everywhere.*)

Who is nursing who?

TONIO: I'm talking of the wounded nursed by the Countess Burita.

GOYA: Don't shout when you mention her name!

TONIO: Not Cayetana.

GOYA: You hold your head like a man who believes in God. Not like me. It's a question of the chin. He holds it up for you.

TONIO: She's twenty-two. Her hair would come down to her feet, I think.

GOYA: At dawn her body weighed nothing.

TONIO: Her?

GOYA: Cayetana's.

TONIO: Desire is cruel, desire is like hope. It summons you by name. And there's nothing can quench it.

GOYA: Why doesn't she nurse you?

TONIO: With me you can never get rid of hope. Trying to get rid of hope is a lost cause with me.

(*Enter* DWARF *to proclaim on pile of rubble.*)

DWARF: Heroic people of Saragossa, city of two cathedrals, take heed and listen, for it is your very own General Don José Palafox who speaks to you. At this hour I'm not asking you for courage. You have proved you have enough, and to spare. You have listened to me and redoubled your efforts to implement the fortifications of the city. I am speaking now to warn you that the evil, which comes from the Devil's side of the Pyrenees, does not only take the form of cannon balls and shrapnel, musket fire and sabres. This same evil can insidiously enter your mind and the minds of your neighbours. Everywhere in our city Treason is today waiting for its chance. There are traitors among you. Be vigilant,

people of Saragossa. Banish the enemy within! Denounce
those who, disguised beneath cloaks like your own, harbour
poisonous thoughts against King and Country. Denounce
the spies! Denounce the traitors! Denounce the heretics!

TONIO: The French sent us an ultimatum an hour ago. It was
three words long. *Peace and Capitulation.*

(DWARF *comes into ruined room.*)

DWARF: In the New Market there's not a scrap of food of any sort
for sale, only men hung from gibbets. Spaniards hung by
Spaniards. Under the arches a few crouch over fires cooking
something. (*Hands bread to* GOYA.) It's for you, Don
Francisco, a present from a phantom under the arcades.

GOYA: The reply?

TONIO: War to the death, guerra a cuchillo.

(GOYA *takes out a packet, wrapped in cloth, from under his shirt
and throws it on the table.*)

Drawings?

GOYA: No. Money. Money for the defence of Saragossa.

TONIO: My friend!

GOYA: I've been well paid by the French.

TONIO: WHAT?

GOYA: Arts, crafts, services.

(TONIO *tries to embrace* GOYA, *who seizes* TONIO's *sabre and
makes to attack his own cape, hung on a nail.*)

Give a cape to a thief and it will hide his loot. Give a cape to
an informer and he will pass unnoticed. Give the power of
the cape to a caudillo or a Führer or a madman in the
Pentagon and he'll liquidate, burn alive, make bombs in the
form of toys. Slash the capes! Slash the shirt beneath! Slash
the flesh! Slash the guts! Slash the heart! What do you see?
Darkness. Nothingness. Blackness. Blackness, Tonio, only
blackness.

TONIO: No. Francisco, no. We never die. Saragossa will triumph.
Nothing on earth can put an end to us.

GOYA: You forget one thing.

TONIO: Tell me.

GOYA: You forget fatigue. It's like rust, fatigue. It eats into the
strongest wills, saps the noblest energies, turns into red dust

the most fervent hopes. Finally, fatigue chooses the easy solution, the shortest answer, whatever is at hand. It doesn't happen immediately, it takes its time, but before the end, fatigue, the exterminating angel of fatigue, takes over.

TONIO: Saragossa is resisting. This is the truth before our very eyes. And the same truth is here – in our hearts.

GOYA: You can hardly stand on your feet.

TONIO: So long as Saragossa withstands, she resists for everyone now and in the times to come. Saragossa salutes Stalingrad! And you, Francisco, you're our pledge, a pledge that what we're living will never be forgotten. Promise me, Francisco, PROMISE ME!

GOYA: You believe in promises, my poor Tonio, at a moment like this!

TONIO: It's not true you have no more faith, Francisco, I don't believe it. You are faith itself. Faith can't leave you. (*He gets to his feet with difficulty.*) They need me out there. (*He picks up packet of money.*) We'll buy saltpetre, bandages, medicines, gunpowder.

GOYA: Each step you take hurts you.

TONIO: That you should have come, it's a miracle. Watch us, Francisco. The corpses between sandbags. The cruelty. Watch us. Every birth and every ruin is a window that gives on to God. Remind him of our glory!

(*Exit* TONIO. GOYA *puts cloak on his shoulders, comes to the table, takes notebook. For the first time the deafening noise of bombardment. Lights fade.*)

ACT TWO

SCENE 3

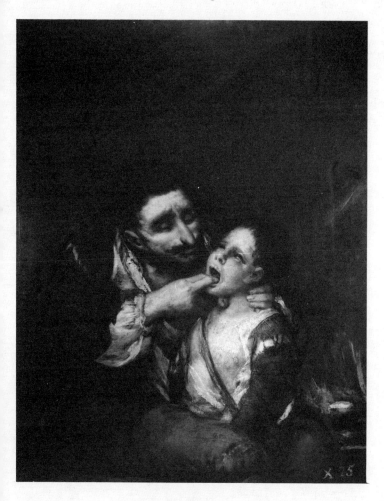

Lazarillo de Tormes
(Private collection, Madrid)

End of winter afternoon. Widow as GOYA'S MOTHER *in her kitchen.*
(By entrance to chapel.) She is seated at a table, peeling potatoes.
Enter GOYA, *exactly as seen in previous scene.*

MOTHER: I met the curé this afternoon. He's pleased with you.
 He says you draw well. Nobody in Fuendetodos has ever
 seen such beautiful drawings. Say your prayers and eat your
 muffin, I've kept it warm for you. Take your time, don't be
 in such a rush, you'll burn your tongue. You rush at
 everything. You eat too fast, it's gone before you can say
 Jack Knife. You pray too fast. Do you hear me, Chico?
GOYA: I can hear you, Mother.
MOTHER: They say you're making a lot of money at school, is that
 true?
GOYA: Five hundred reales per head painted. It varies according
 to the sitter. Sometimes a thousand.
MOTHER: Be thrifty, Chico. The smarter the clothes, the dirtier
 the mud that sticks. Be thrifty with yourself and your
 earnings. Have you thought of what you'll leave behind?
GOYA: It's being prepared.
MOTHER: That's good. Take your time.
GOYA: I have some money for you.
MOTHER: Keep it, I don't need anything now. Ghosts have no
 needs – it's a strange advantage. At nine months you were
 already walking. You stood on a stool to look out of the
 window. I was still nursing you at the breast. And at ten
 months you were running.
GOYA: I think I'm ill, Mother.
MOTHER: None of us has ever died of deafness. If you don't hear,
 you have to look harder.
GOYA: My head goes round and round and there's a ringing like a
 bell. Things scratch and boom and fly in my head. Djinns
 and gnomes and vampires, bats and suckers and tell-tales
 with eyes of owls and cats' paws. Am I mad, Mother?

65

MOTHER: At school you'd do better to listen to your teacher. Eat
 your muffin and spread the butter on it. Shh! Your father's
 come back from Saragossa on the mule. These days he earns
 five reales a week, gilding frames. Now wash your hands,
 Chico . . . The gold leaf sticks to his thumbs and frightens
 the birds. Do what I say, Chico sweetie, only onions make
 you cry. Don't ever forget the candles for the Nuestra Señora
 del Pilar. When you're a man, you'll be happy, don't forget.
 Does your wife Josefa take good care of you in school?
GOYA: She is so light, Mama. She's scarcely there. She can do
 nothing for me.
MOTHER: She can do nothing, she can do nothing – how could she
 do anything for you? Even her offspring don't live more than
 a few days. People say she smothers them.
GOYA: The children, my children – they're my fault, Mama.
MOTHER: There's no love in her heart. That's the beginning and
 end of it. Neither for you nor for the children.
GOYA: It's my fault.
MOTHER: Women are cruel, Chico, many are witches. They
 dream only of sucking you dry, blood and brains.
GOYA: Their breasts are so soft to touch, their skin so white and
 their eyes like coals to warm you.
MOTHER: You see, Chico, it's better now. Everything's better.
 Have a little sleep. It's a long way to Madrid from
 Fuendetodos.
 (*Darkness.*)

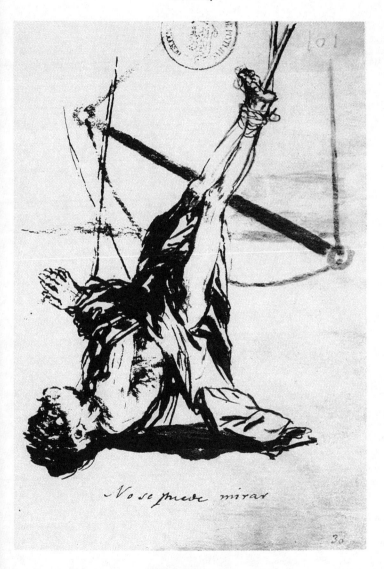

No se puede mirar
(drawing for Los Caprichos, The Prado, Madrid)

Day. Aragon (1809). GOYA, *led by* DWARF, *is crossing an arid landscape of boulders, made in the cemetery. The colour of rust.*

GOYA: We are being watched all the while.

DWARF: On this stage of rocks I can't see a soul. Not a horse, not even a mule, has passed along this road since midday.

GOYA: If you want to speak to me, you'd better climb on to a rock, I can't keep bending down all the time.

DWARF: In which case should we carry a rock with us? CARRY IT?

GOYA: Why not? You can carry it, and it'll serve us as a permanent hiding place.

DWARF: The only problem is one of choice. How to choose one rock from so many?

GOYA: Ours is a country of broken mountains.

(*They stop.* DWARF *picks up rock.*)

DWARF: I try to imagine that instead of my carrying this rock, it's you.

GOYA: If only we could exchange! You take my load, I'll carry your rock!

DWARF: (*Cunningly*) It wouldn't work. Like that I wouldn't have anything to stand on, and you wouldn't hear me.

(*They walk on.* DWARF *stands on rock.*)

Do you think there's an end?

GOYA: To what?

DWARF: This.

GOYA: No.

DWARF: Saragossa fell.

GOYA: With those who fought there.

DWARF: Fifty thousand souls departed.

(*They walk on.*)

GOYA: The sight of agony is more terrible than the sight of death.

DWARF: I'm going to put the rock down here because I think we should hide behind it immediately.

(*They hide behind rock.*)

GOYA: Tonio is dead. I can see his corpse, stiff.

DWARF: Better think of his glory in the everlasting annals of Saragossa.

GOYA: What do you hear?

DWARF: Nothing. Nothing at all. Not a horse, not a mule, not a soul on the steppe. The rock was too heavy, that's all . . . I wish we were in Madrid. They have fireworks every night to celebrate the Saint Napoleon! Imagine the rockets above the Puerta del Sol! The sparks falling like confetti. Our Joseph has abolished all feudal duties to the Señores. We're becoming the Promised Land.

GOYA: Let's get to our feet and continue.

DWARF: Do you hear the vultures?

GOYA: I can't hear. Do you want me to repeat it?

DWARF: Perhaps they heard the news from Madrid. Perhaps that's why they're squalling.

GOYA: Fewer cloaks, fewer cloaks! Fewer cloaks! That's what they cry. Lift it up again.

DWARF: No question, this steppe has a soul. Look at it! *Nada*. An army can cross it and it's like a ship at sea, it makes a wake.

GOYA: Lift it up again.

DWARF: Then in no time it disappears without a trace, without a single trace.

GOYA: I'm going to sit on it whilst you carry it.

DWARF: I'm not strong enough.

GOYA: You underestimate your powers. There's already a town on your rock.

DWARF: I'm going to put the rock down because I think we should hide behind it immediately.

GOYA: You said that before. It turned out to be laziness.
(*They hide behind the rock.*)

DWARF: Cover your face, hide your papers and look hungry!
(*Enter* LEANDRO *dressed as a bandit with pistol. He kicks at the two lying figures.*)

LEANDRO: On your feet, both! Hands up high.

DWARF: If we had any arms, we'd have sold them long ago in the hope of acquiring a bite to eat.

LEANDRO: Money? Gold? Jewellery?

DWARF: Young man, what do you expect? You must be new at the game. This is the eleventh time we've been robbed! (*Glances at* GOYA.) No, I won't exaggerate. It's the third. We have nothing left. Search us.

LEANDRO: Where are you making for?

DWARF: He's deaf, he can't hear. I have to step on the rock there to make him hear.

LEANDRO: What's his business?

DWARF: Poultry.

LEANDRO: Where have you come from?

DWARF: Chickens, geese, duck, pheasants, guinea fowl, quail, hoopoes, linnets, nightingales.

LEANDRO: Open his cloak.

DWARF: Not a feather now. He lost them all. That's why we had to leave.

LEANDRO: Did the French pillage you?

DWARF: (*Hedging*) A bit of French, yes, these days you can never be sure. A bit of wolves too. Every feather gone.

LEANDRO: I'm taking you back to the camp. The Tinker has to question you.

DWARF: The Tinker?

LEANDRO: Before he took to the mountains, he ground knives in the villages.

DWARF: There's no point in questioning him (*He nods at* GOYA.) He can't hear.

LEANDRO: Did you pass any troops?

DWARF: I'll ask him . . . No, he says, it wasn't a wolf, it was a fox. He hasn't seen any French since he sold them his last goose. This goose was a favourite of his and when he had to part with her, he had tears in his eyes.

LEANDRO: Don't fuck around with me.

DWARF: He understands nothing about what's going on. He can't hear. He doesn't know the difference between a tortilla and an omelette. You haven't by any chance got anything to eat? It's been days.

LEANDRO: On your feet! I'm taking you to the Tinker.

DWARF: It's a fine flask you've got there, *guerrillero*, I wonder what's in it – water?

LEANDRO: You covet what's in the bottle, dwarf?

DWARF: For us it has a medical use. A few drops in each ear and the hearing comes back a little.

(LEANDRO, *gun pointed, starts to walk the two men off.*)

LEANDRO: I warn you. We are learning to count in the mountains now. For one Spaniard dead, we kill four prisoners. And we don't waste precious shot and powder on them. We chase the *gavachos* and their friends over the cliff.

DWARF: That's justice, *guerrilleros*!

LEANDRO: The *gavachos* raped two nuns in Asasua and cut off their heads. The *gavachos* took two of our wounded and impaled them on the branches of a fruit tree. Two and two make four, so the Tinker counted sixteen. Sixteen at the foot of the precipice there.

GOYA: And so it goes.

LEANDRO: What did the old man say?

DWARF: He says you'll fight till the last *gavacho* is kicked back over the Pyrenees. He says there's no other people on earth who defend their country – like we Spaniards defend our Spain.

(*Exit* LEANDRO *with his two prisoners. Sudden darkness.*)

ACT TWO

SCENE 5

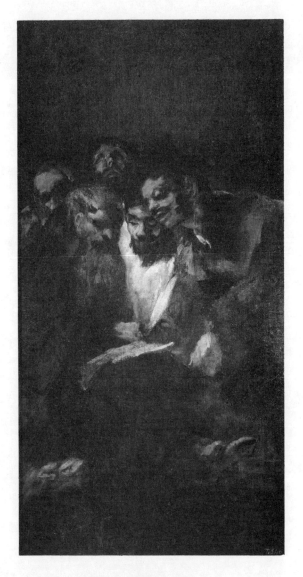

Hommes lisant
(The Prado, Madrid)

Evening (1809). Two chairs and a table with many papers on it, set back before a semi-transparent curtain. Behind the curtain a firework display. FEDERICO, *seated at the table, is watching the display.*

FEDERICO: 'Let Socialism be
in the teeth of all conflicts
for us a monument struck
in common bronze.'*

(*Enter* DOCTOR *hurriedly.*)

DOCTOR: Calls everywhere. Rushed off my feet, my friend. All the French with stomach complaints. But you – I must say you look in very good shape. Fine fettle.

(FEDERICO *offers* DOCTOR *a glass.*)

A strange phenomenon and it's not the first time I've noticed it. Men come out of prison either broken or with more energy than before. And that's your case, if I may say so, Don Federico. I wonder at times if I shouldn't prescribe a mild dose of incarceration as a cure for lassitude, ennui, disinterest. That makes you smile?

FEDERICO: The only thing to be said for a cell, Doctor, is that you can learn in it a certain detachment from the present and a certain receptiveness, I'd almost say tenderness, towards the future.

DOCTOR: The future?

FEDERICO: Tell me, do you believe there's such a thing as progress in the science of medicine?

DOCTOR: Undoubtedly. Though the idea of progress doesn't suppress pain as effectively as morphine.

(*Behind the screen the flaring of fireworks in the sky.*)

Look! Fireworks. And not, for once, cannon fire!

FEDERICO: They were already dancing in the park when I came home.

*From a late poem by Mayakovsky.

DOCTOR: (*Touching papers on table*) A new publication? May I ask what it's about? Your imagination in full flight?

FEDERICO: It's a translation.

DOCTOR: From what foreign language?

FEDERICO: Not exactly from a foreign language. Rather it's a rendering into the language of today the experience of the future.

DOCTOR: Ah! That's unexpected. I've recognized for a long time the gifts of your intelligence and your reasoning, but I was altogether ignorant of your gift of prophecy. May I?
(FEDERICO *nods*, DOCTOR *takes the top page, reads:*)
>'Let Socialism be
>in the teeth of all conflicts
>for us a monument struck
>in common bronze.'

Socialism? The word must come from the Latin *socius*, no? Something to do with word *society*; or the word *social*, I suppose. What do you understand by it? Socialism?

FEDERICO: It is what I'm working on whenever I have a minute. More or less it refers to the organization of a social body for the benefit of the common good rather than private interest. Based on a principle which is the opposite of egoism.

DOCTOR: Not so fast . . . not so quick. A social body? I have enough trouble with each individual human body. Can you think of society as being like a body? Above all, can you construct a society, a body, as you deem fit?

FEDERICO: That is our task. It will take a long time.

DOCTOR: Are you sure you will not find yourself in opposition to what is natural and perhaps changeless? Let me give an example from the human body. The heart. Blood flows from the heart by the left ventricle and returns through the veins to the right ventricle. Is it possible to imagine this flow being reversed? The blood leaving the heart at the right and entering at the left?

FEDERICO: Surely not. But with a social body anything is possible. It is man's creation.

DOCTOR: There's a suspicious whiff of poetry in what you are proposing.

76

FEDERICO: Perhaps. The poetry of history's Sundays.

DOCTOR: (*Re-reading*) 'Let Socialism be
 in the teeth of all conflicts
 for us a monument struck
 in common bronze.'

There's a certain energy in the words, I'll admit that. Where do they come from?

FEDERICO: From the future. These lines will be written by a man who will end up, at the age of thirty-seven, killing himself with a bullet in his heart.

DOCTOR: A sad prognosis.

FEDERICO: Yet in that idea is everything which makes sense to me. The Adam of a new world.

(*Fireworks brighter than ever.*)

Otra en la misma noche
(drawing for Los Caprichos, The Prado, Madrid)

Night. The cemetery as steppe. GOYA *and* DWARF *are trying to sleep between the rocks.*

DWARF: The Tinker liked his portrait.

GOYA: What did the animals do to deserve being punished by the arrival of man? Did they sleep too much before? Did they repeat the same things too much over and over again? Didn't they make good enough theatre – the animals for the giants?

DWARF: It saved our lives your portrait of the Tinker.

GOYA: The giants got bored and so they had the idea of inventing man for their entertainment.

DWARF: Animals may be dumb but they're not stupid. The only difference is: they don't like stories. And we – we like nothing else but stories. They kill us, they torture us, they drive us mad, our stories, and we live off them. Meanwhile our stories make the giants laugh, they break their ribs. And who makes them laugh the most? I do. Amore, the Dwarf. They started laughing as soon as I dropped out of my mother's belly – they saw the comedy before I'd opened my eyes. You don't make the giants laugh much, Don Francisco, you are too similar. You take after them.

GOYA: I can still hear the dog howling, the same dog.

DWARF: You've got better ears than I have.

GOYA: Can't you hear it?

DWARF: Yes. I can hear your dog.

GOYA: You're lying again, you can hear nothing.

DWARF: I hear, they hear, you don't hear. So what? I want to sleep and you're becoming a pain in the arse with your lies and your exaggerations. And your truth! You are possessed by the truth, Don Francisco. And I'll tell you something else. Truth is dead and buried. No one remembers when or how it happened. But it has happened.

GOYA: What?

DWARF: Buried, yes, like your sardine, covered with muck and stiff and full of worms, your sardine of a truth.

GOYA: Tomorrow we must look for a mule.

DWARF: If we don't wake up with our throats cut.

GOYA: I have told you before not to exaggerate.

DWARF: It happens.

GOYA: I can't hear. If our throats are cut, we don't wake up. If we do wake up, you look for a mule.

ACT TWO

SCENE 7

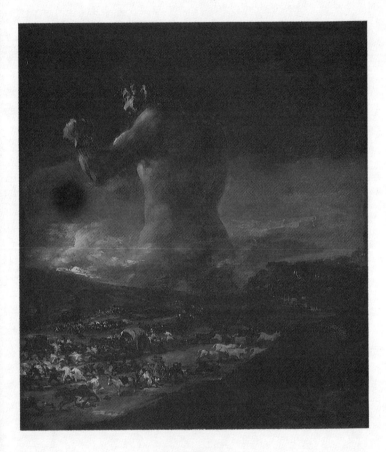

The Collossus
(The Prado, Madrid)

*Grey day (1811). The cemetery arranged as a room in Goya's house,
Madrid. A large elegant table. Curtains either side of a tall window
giving on to the street. A mirror with a gilded frame. A large indoor
potted plant. The* DOCTOR, *exhausted, sprawls in a chair. Right of
stage* GARDENER *is hanging prints to dry on a clothes line. (They look
like large white stiff handkerchiefs. The printing is on the other side.
We see nothing of the image.)* DWARF *is looking out of the window, as
though at a television screen.*

DWARF: It looks to me like the same dog. The one who comes out
of his head. The dog who hurts him so much, with orange
eyes. Yes, it's the same dog.
(DOCTOR *comes to end of table, on which lies a sheep's head and
two sides of mutton, as in a butcher's shop.*)
DOCTOR: This meat is bad. Indisputably bad and should be
thrown away. I thought I could smell it from the chair over
there.
GARDENER: He insists. He says he needs it.
DWARF: The dog is following an old woman carrying a bundle.
DOCTOR: Famine in Madrid, the price of bread going up each
week – a loaf now costs 30 centimos, that's three times the
price of a pass with a tart.
DWARF: Don't exaggerate. I've learnt that. Nothing is to be
exaggerated, Doctor. The street smells of sulphur. I can
smell it through the window.
GARDENER: (*Hanging another paper*) Twelve copies of 'They don't
know what they are doing'. He was never clever – I've told
him – at titles.
DOCTOR: Clever enough in other ways though. You have to be
clever to let meat rot like this. Enough meat for a dozen
people! A baturro never changes. The Duchess was right.
They're like mules. Two months ago they were burning their
own crops to prevent them falling into the hands of the
French. Today they're starving. A visceral irresponsibility.

85

GARDENER: He won't let anyone remove it.

DWARF: The woman with the bundle and another woman are coming to beg at the door.

GARDENER: He won't be long now. He's putting the finishing touches to a portrait.

DOCTOR: Portrait!

GARDENER: A portrait of General Nicolas Guye.

DOCTOR: The job never stops, does it? (*Knocks on door of Goya's studio.*) Bubonic plague on the outskirts of the city, no road open anywhere, cholera, typhus . . . and you are putting the finishing touches to a portrait! The world is slipping into hell and you are finishing a portrait. On the day before the Last Judgement narcissism reaches its apogee.

DWARF: The two old women have gone away with nothing. One of them is taking off her shawl. She's not old. She's simply not hungry enough yet to prostitute herself. Next week she'll come in mantilla and garters.

(*Enter* GOYA *from studio carrying General's brocaded military tunic which he throws on the table beside the meat.*)

GOYA: Why do you make so much noise?

DOCTOR: (*Shouting*) You should get rid of that meat, it can breed infection in a time of pestilence. Do you understand what I say?

(GOYA *hangs tunic over edge of table, picks up the sheep's head and places it in the collar of the tunic. He steps back to look at the effect.*)

I've come to offer you my congratulations. Congratulations on the honour you've just received from the Court.

GOYA: Pasture is to sheep what air is to birds and water to fish.

GARDENER: He hears what he wants now. Nothing else.

DOCTOR: I want to congratulate you on receiving from the Emperor Joseph Bonaparte the Royal Order of Spain.

GOYA: Sheep believe pasture is not only their sustenance but also their protection. When they flee, they believe the pasture will protect them with its infinite distance. When they charge over a cliff, they do so in trust not fear.

DOCTOR: It's my duty to insist, my friend, that you wash your hands now.

(*Enter* FEDERICO, *wearing the red sash and star of the Royal Order of Spain.*)

FEDERICO: (*To* GOYA) I'm wearing it for you! We're twins.

DWARF: In the street they call it the Order of the Aubergine. They say too that Joseph Bonaparte sits astride a cucumber not a horse.

GOYA: I painted Juan Antonio Llorente wearing his. That's enough for me.

FEDERICO: There are honours we could do without, aren't there, Paco?

DOCTOR: In times like these you have to keep your hands clean.

(FEDERICO *takes off sash and slumps in chair.*)

FEDERICO: The Royal Order!

DWARF: Two French soldiers coming down the street . . .

FEDERICO: (*Pensive in chair*) Who decides who is to survive?

GOYA: I have a favour to ask you.

DOCTOR: Any service I can offer. I have my instruments and phials with me – they're downstairs. Don't hesitate. We've done everything. We've looked up the arses of Bonapartes. We've curetted duchesses –

(GOYA *seizes* DOCTOR's *throat with one hand. His words stop. No one notices except* GARDENER *who passes* GOYA *one of the pegs from the line on which the prints hang.* GOYA *clamps the peg on* DOCTOR's *mouth.*)

DWARF: Two young ladies have approached the French soldiers. With my expert eye I'd give their fathers an income of at least two thousand reales.

GOYA: (*To* DOCTOR) You're going to sign my will. It needs a witness.

(GOYA *unclamps peg.*)

DOCTOR: You are not well, Francisco, you are on the brink of one of your crises. So I will forgive you.

DWARF: One lady is twirling her shoes on her foot. They've settled for a loaf of bread for the two of them.

FEDERICO: (*Looking at etchings*) One, two, three, four, five . . . Each one practically the same. You followed my advice. Remember, Paco? The day they arrested me.

DWARF: An old man has fallen against a wall. He can't get up.

GOYA: (*To* FEDERICO) You look tired. Your forehead looks tired.

FEDERICO: There's no other way, Paco. To pull ourselves out of two centuries of stagnation, to come out of the dungeon, out of the interrogation chamber, the cellar, the graveyard, the secret office – to come out of the blackness into the first light, the very first light; others will come later at noon to follow us. We are right. But we are so alone. We who want to be fathers are like orphans. Can you hear me?

DWARF: The dog is foraging the old man who fell down.

GOYA: The season when they shear the sheep in Aragon and pick the first apricots. The third of May. From that hill, behind the cemetery, you can see at night the lights of the city below. Down there the children are sleeping and my wife is watching the door, biting her fist, waiting for me to return. Up here the French are shooting us one by one. Blindly, deafly. They don't even have to take aim. Their muzzles are so close. Every one of us is waiting to die. Anselmo Ramirez de Arellano, Juan Martinez, Antonio Mazias, Mendez Villamil, Antonio Zambrano . . .

FEDERICO: Stop, Paco! It doesn't suit you. It sounds like a litany.

DWARF: The dead cart's coming with its bell. He can't hear it.

FEDERICO: If our people instead of the French had been in command on your third of May, Francisco, the reprisals would have been even worse. Do you know what Antonio head of our city junta said? I have a terrible memory for words. 'Thank God,' said Antonio when he heard of the executions on the Montana del Principe Pio. 'Thank God there is still at least one army in the world who can hold down a mob!'

GOYA: Out of my sight! Finish! One, two, three. The third man to die is wearing a white shirt and trousers the yellow of lemons. He's falling. Between the order to fire – *Feu!* – and the end of a life, there's time to foresee everything.

(GOYA, *back to the audience, looks towards the window. In it appears a man, face contorted, arms outstretched, wearing a white shirt and lemon trousers.*)

DWARF: Two men have kicked the dog away and are taking off the boots of the old man who is dead.

GOYA: I do not know who chooses what I see. Not me, dear God, not me.

(GOYA *takes his head in his hands and walks like a blind man towards the window. The figure disappears. Only* GOYA *has seen the figure.* GARDENER *takes* GOYA's *arm and leads him through the door to the studio.*)

(*To* GARDENER *as they leave*) There's a terrible noise in my head. Like water. Like water, unstuck from the earth and drawn by the moon . . . prepare me a canvas for tomorrow. Three hundred and fifty by two hundred and seventy.

DOCTOR: He has these attacks. There's nothing to be done. Just leave him to paint!

(FEDERICO *is seized by a coughing fit.*)

FEDERICO: Can you stop this?

DWARF: The first man has run off with the old man's boots. The second man is chasing after him.

DOCTOR: At night if one can't sleep and one is alone, coughing is almost inevitable. One needs a lady, preferably one with a smooth skin and a good circulation. Caressing is the best cure for nocturnal coughing. The material of the sheets can play a role too.

FEDERICO: (*Between coughs*) It's not night yet and I'm coughing. (*Enter* GOYA *with paper, followed by* GARDENER. *He has recovered his equilibrium.*)

GOYA: Here's the will. Apart from a few bequests to friends, it makes over everything to my wife and my one remaining child, Xavier. I want them to have the wherewithal to be secure. You sign here.

DOCTOR: Your optimism amazes me! In times like ours an inheritance can promise nothing.

GOYA: I can't hear. Please sign.

GARDENER: (*To* FEDERICO) In times like ours, trees, I have noticed, live longer than laws.

FEDERICO: (*Still coughing*) We are planting the Tree of Liberty, mia amigo. One day those who till the land will own it.

GOYA: I like to think of Xavier's children lacking for nothing.

DWARF: It's begun to rain. Everyone's running for shelter. The wind has blown a wet paper, which is sticking on to the face of an old man who is dead. The dog's come back.

ACT TWO

SCENE 8

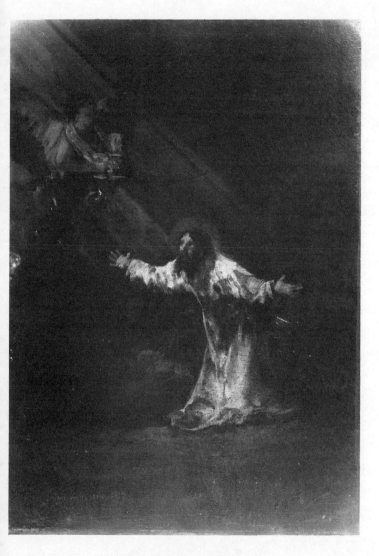

Christ on the Mount of Olives
(Church of San Antonio, Madrid)

Night (1811). The same as previous scene except that the line, on which prints are pegged, now crosses the whole room. GOYA *is fingering the prints on the line.* GARDENER *is splitting wood with an axe for the fire.*

GARDENER: I brought in the barosma plants this morning. I've never known such cold so early. I was a bit frightened for them.

GOYA: Frightened for what?

GARDENER: The barosma plants.

GOYA: In God's name what are they?

GARDENER: The little bushes in pots with white flowers. The ones in the courtyard.

GOYA: White, did you say?

 (GARDENER *nods.*)

 Blind! All of you. You're blind! The flowers you're frightened for are pink. Not white. White, if you must, but stained with blood. Stop! Don't move your arms. Keep the axe there, Juan.

 (GARDENER, *with axe raised above his head, freezes.* GOYA *continues to examine prints.*)

GARDENER: If you need a drawing, Don Francisco, better do it quickly.

GOYA: Keep the axe there! Drawing! Drawings come by themselves. You just untie the sack, lift it up, tip it, and out pours the debris. Drawings are debris. Don't move, Juan.

GARDENER: I have to now.

GOYA: I thought you were strong. I thought you had the shoulders of a bull.

GARDENER: There's a louse in my armpit.

GOYA: Don't move. Which one? I'll find it for you.

GARDENER: The left.

 (GOYA *pulls up* GARDENER's *shirt, searches, spectacles on the end of nose.*)

GOYA: Can see nothing! Need a candle.

GARDENER: (*Starting to laugh*) It's tickling.

> (GOYA *steps back.* GARDENER *lowers axe and splits wood.*)

GOYA: I wanted to give the log at your feet a little more time.

GARDENER: In the circumstances a double cruelty.

> (GOYA *doesn't understand.* GARDENER *takes paper from table and writes on it:* DOUBLE CRUELTY.)

GOYA: If logs could see, if they had eyes, if they could count minutes, it would be better for the axe to descend immediately. But logs can't count.

GARDENER: You've never heard what they call men in Malaga?

GOYA: Men?

GARDENER: They call a man a log with nine holes!

> (GOYA *counts the holes.*)

GOYA: Did you find any rice today?

GARDENER: No. The French took everything before leaving, and what they didn't take the British have pillaged. Either that or people don't want to sell to us any more. They look dangerous when I ask. In my opinion, Don Francisco, we should prepare to go into hiding. Only the illness of Doña Josefa has prevented me saying this before. I know a place where we can go.

> (GOYA *appears not to have heard.* GARDENER *writes on paper:* HIDING?)

GOYA: There's not the slightest cause for alarm. I've already offered my services to the victors. Conquerors need painters and sculptors. Never forget that. Victory is ephemeral – as ephemeral as played music. Victory pictures are like wedding pictures, except there's no bride present. The bride is their own triumph. I don't know why, but it has always been so throughout history. So they want mother-fucking portraits of themselves with their invisible bride. And I can do these portraits like no one else can. I have a weakness for victors – above all for their collars, their boots, their victory robes. I think we were all meant to be triumphant. Before there was any destiny, we were children of a triumph. We were all born of an ejaculation.

> (*Enter* DOCTOR.)

DOCTOR: Your wife is asking to see you. I have one thing more to say to my husband, she says.
(*Exit* DOCTOR *hurriedly*.)

GOYA: Soon I'll do the Duke of Wellington. He insists upon a horse.

GARDENER: Don Federico has already gone into hiding.

GOYA: When the Whore's Desired One returns to sit on our throne, I shall paint him with a sword under his hand and a cocked hat under his arm. And if he won't sit for me, I'll paint him from memory. (*Looks in mirror.*) Everyone will forgive me.

GARDENER: The washerwomen say you're not so deaf you don't hear the clink of reales in the money bags. That's how you know when to change sides, they say.

GOYA: Everyone will forgive me.
(*Enter* DOCTOR.)

DOCTOR: I regret to have to tell you, Don Francisco, it's too late. Your wife is dead.
(GOYA *falls to his knees*.)

GOYA: Even my wife will forgive me.
(GOYA *remains kneeling with bowed head. Imperceptible sound of the sea. Abruptly he scrambles to his feet.*)
If only men didn't forgive!
(GOYA *grasps the clothes line with both hands and walks beside it, holding it like a man in a gale.*)
Do you know how much is unforgivable? Do you know there are acts which can never be forgiven? Nobody sees them. Not even God.
(*Sea becomes louder.*)
The perpetrators bury what they do from themselves and others with words. They call their victims names, they fasten labels to them, they repeat stories. Everything is prepared by curses and insults and whispering and speeches and chatter. The Devil works with words. He has no need of anything else. He distributes words and with the innocent working of the tongue and the roof of the mouth and the vocal cords, people talk themselves into evil, and afterwards with the same words and the same wicked numbers they hide what

they've done, so it's forgotten, and what is forgotten is forgiven.

(GOYA *comes to a print.*)

What is engraved doesn't forgive.

(GOYA *falls to his knees.*)

Do not forgive us, O Lord. Let us see the unforgivable so we may never forget it.

(GOYA *somehow gets to his feet, walks to exit where* DOCTOR *entered.*)

Forgive me, Josefa, forgive me . . .

ACT THREE

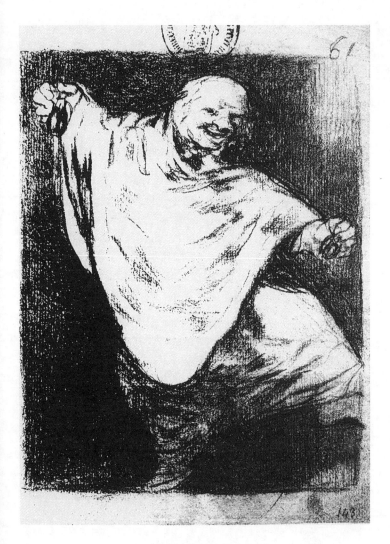

Fantasma con castanuelas
(The Prado, Madrid)

Early spring morning (1827/8). Sunshine. The garden of Goya's house in Bordeaux. (The scene is almost identical with that of the cemetery.) GARDENER *on ladder is pruning a vine against a wall. Enter* GOYA *with stick (now over eighty), accompanied by* FEDERICO *(same age).*

GOYA: *(Pointing)* There's a Goldfinch, there in the almond tree – do you see him?

FEDERICO: I tell you every morning, Francisco, my eyes are failing.

(The two old men stand still. GOYA *imitates song of Goldfinch.)*

GOYA: That's how he sings, Goldfinch.

FEDERICO: How do you know?

GOYA: *(Not hearing)* Would you like to hear Nut Hatch? Pepa teaches me. Bird by bird she teaches me their songs.

FEDERICO: Your new painting?

GOYA: Two centuries ago in Amsterdam a Dutchman painted Goldfinch.

FEDERICO: *(Shouting)* How's the new painting?

GOYA: Sky's wrong behind the head. Never had trouble with a sky before.

FEDERICO: French skies are not the same. Look at it. Milky. French bakeries are different too. With age, I regret to say, I find myself from time to time becoming greedy.

*(*FEDERICO *takes a brioche out of his pocket, offers half to* GOYA. *They sit.)*

GOYA: Have you said yet: 'With age, I regret to say, I find myself from time to time becoming greedy'?

*(*FEDERICO *throws crumbs to the birds.)*

I slept better this night. No dreams. That's why you arrived before I was up.

FEDERICO: Didn't matter. I had plenty to think about . . . there are spies from the Holy Office sent here to Bordeaux. I'm sure of it. Don Tiburcio has refused to give us any more money for the paper.

GOYA: Which one?

FEDERICO: Our paper in Spanish – the one I edit.

GOYA: I'll do a lithograph for you.

FEDERICO: The only explanation is that they threatened to maltreat Don Tiburcio's family in Valencia. Meanwhile we owe three hundred to the printer.

GOYA: Soon there'll be more exile papers in the world than stars in the sky.

FEDERICO: Just three hundred to pay the printer.

GOYA: My lithographs aren't selling. People don't want to know. They want everything in colour and stereo . . . What's the latest news from our country?

FEDERICO: The latest! The dark ages. The Constitution annulled and void. Thought manacled. People disappearing in the streets. Torture. Electric shocks. Underground garages. The gluttony of terror. The same as I tell you every morning, my friend. Will anybody ever bring news of a different sort? The latest, Paco, is that we're already living in the future. Not the one we fought and died for. The one the giants substituted for ours . . . That's the latest. Will it ever be different?

GOYA: If you're quiet for a moment, I'll do Nightingale.

FEDERICO: If I didn't know better, Frogman, I'd say you'd gone simple.

GOYA: Then don't ask simple questions like: 'Will anybody ever bring news of a different sort?'

FEDERICO: So you heard me?

GOYA: Of course not.

FEDERICO: Everywhere the restoration of the past. Everywhere boasts about what was once thought shameful. (*Shouting*) Tell me what's left of our hopes.

GOYA: This! (*Imitates Goldfinch.*) What's left of our hopes is a long despair which will engender new hopes. Many, many hopes . . . I'm going to live to be as old as Titian.
(*Enter* PEPA.)

PEPA: Your hot chocolate is waiting in the house.

FEDERICO: Everything should be clear, except hot chocolate which should be thick.

GOYA: Has he said it again?

(PEPA *nods and takes* GOYA's *arm. Exit* FEDERICO *and*
GARDENER, *carrying ladder, towards house.* PEPA *and* GOYA
*walk slowly towards swing. They speak softly, almost
whispering.* GOYA *has no difficulty in hearing.*)
Have you read the pages I marked of Francisco de Quevedo y
Villegas?

PEPA: All of them.

GOYA: And?

PEPA: They were about the Last Judgement.

GOYA: And the story about me?

PEPA: The painter Hieronymus Bosch finds himself in hell and
there he's cross-questioned. When you were a painter on the
earth, they ask him, why did you paint so many deformed
men? And Hieronymus replies to them: Because I don't
believe in Devils.

GOYA: Correct.

(PEPA *sits on the swing.* GOYA *stands before her.*)
Do you know who is the favourite in the asylum down by the
river? Napoleon! I counted fifteen men wearing hats, and on
the hats scraps of paper with the words 'I am Napoleon'
written on them. Do you know why Napoleon appeals to the
mad?

PEPA: No.

GOYA: Because Napoleon was mad enough to boast, 'I have an
annual income of three hundred thousand men!'

(PEPA *picks some flowers, offers them to* GOYA.)

PEPA: On Friday at 2 p.m. in the Place d'Aquitaine, there will be
a public execution, with the guillotine, French style.

GOYA: I shall be there.

PEPA: A poor wretch called Jean Bertain who murdered his
brother-in-law.

GOYA: Perhaps the brother-in-law was raping his niece. Amongst
men pity is rare.

PEPA: When you feel pity, you close your eyes.

GOYA: I have eyes in the back of my head. They never close. Do
you love me a little?

PEPA: A little, a lot, passionately?

GOYA: If I painted a miniature on ivory it could hang between

your breasts. Am I mad, Pepa?

PEPA: You don't imagine you're a Napoleon.

(GOYA *sits on a stool, takes his head in his hands.*)

GOYA: A man bends double between a pair of lips. He tries to get into the mouth. When he is in, it's very difficult for him to get out. One must name everything one sees for what it is. Never stop looking at consequences. The only chance against barbarism. To see consequences.

PEPA: Don't torture yourself, Francisco. It happens at the end of the morning – and it passes, it goes away. Let's play together. In our family album (*Opens a book on her knees*) I put a picture of a young man. He's wearing a large black hat and he has dark piercing eyes.

GOYA: Doubtless he was very ambitious.

PEPA: Large, sensuous mouth. Strong appetites.

GOYA: In our family album I put a picture of a man standing before an easel.

PEPA: Around the brim of his hat there are candles.

GOYA: He worked all night.

PEPA: Quel panache! He has very smart, tight trousers. And now the same man, older. He's wearing glasses.

GOYA: He'd seen too much.

PEPA: He has a good complexion and he has a white silk scarf round his neck.

GOYA: It was already the year of the French Revolution.

PEPA: In our family album I put a picture of a man standing against a blackness. He looks stunned – stunned by the fact he's still alive.

GOYA: He's simply old – almost seventy. Madrid is infected by the plague and it has killed Amore.

PEPA: The expression changes but it's always the same man.

GOYA: It's perhaps the same man. But it's not me.

PEPA: Yes, it's you and it's your art, you painted the pictures.

(*Suddenly* GOYA *loses interest. He is staring hard at the Duchess of Alba's grave beyond the swing. The* DUCHESS *appears.* PEPA *cannot see her.*)

GOYA: Leave me now, Pepa.

PEPA: Your art, Don Francisco.

GOYA: To hell with my art!

PEPA: You were a prophet. In your art you foresaw the future.

> (DUCHESS *advances towards* GOYA.)

GOYA: Come, come.

PEPA: With such compassion . . .

GOYA: Get out, I tell you, fuck off.

> (GOYA *chases* PEPA *out of the garden with his stick. He turns to the audience.*)

Voyeurs! Fuck off!

> (*His back to audience, he watches* DUCHESS *undress for him, as in a striptease.*)

My darling life.

> (DUCHESS *opens her arms to him.*)

DUCHESS: Everything is for you, every feather. Come, my love, come, come, my frogman.

> (DUCHESS *disappears.* GOYA *falls in a heap on to the ground. The stage is silent. As if the curtain should now come down but the mechanism doesn't work.* PEPA *enters, sits on the ground, places* GOYA's *head on her lap.*)

PEPA: Every time you do the same thing. She always escapes from you. You're never quick enough.

GOYA: I walk on sticks . . .

> (*Enter from different directions all other actors, dressed as they were in the Prologue.* GARDENER, *masked, goes over to beehive.* PEPA *gently disengages herself from* GOYA, *gets to her feet and rings the bell. The actors begin to leave the cemetery exactly as in the Prologue.* PEPA *rejoins* GOYA.)

WIDOW: (*To herself*) Let a little justice come to this earth, dear Lord.

DOCTOR: (*To* ACTRESS) You wanted to seduce your father so you became an actress.

GOYA: (*To* PEPA) Have they finished? Is my portrait done?

PEPA: Yes, it's done.

GOYA: They must sign it.

PEPA: It's done.

GOYA: Am I dead, Pepa?

PEPA: Don't worry. For tonight you're well and truly dead.

> (LEANDRO *is the last to leave.*)

LEANDRO: (*Shouting to* PEPA) Wear your new white dress!

GOYA: That's good . . .

 (GOYA *closes his eyes and sleeps.* GARDENER *blows smoke into hive. White curtain, without image or signature, descends.*)